The Secret Life of the
OTTER

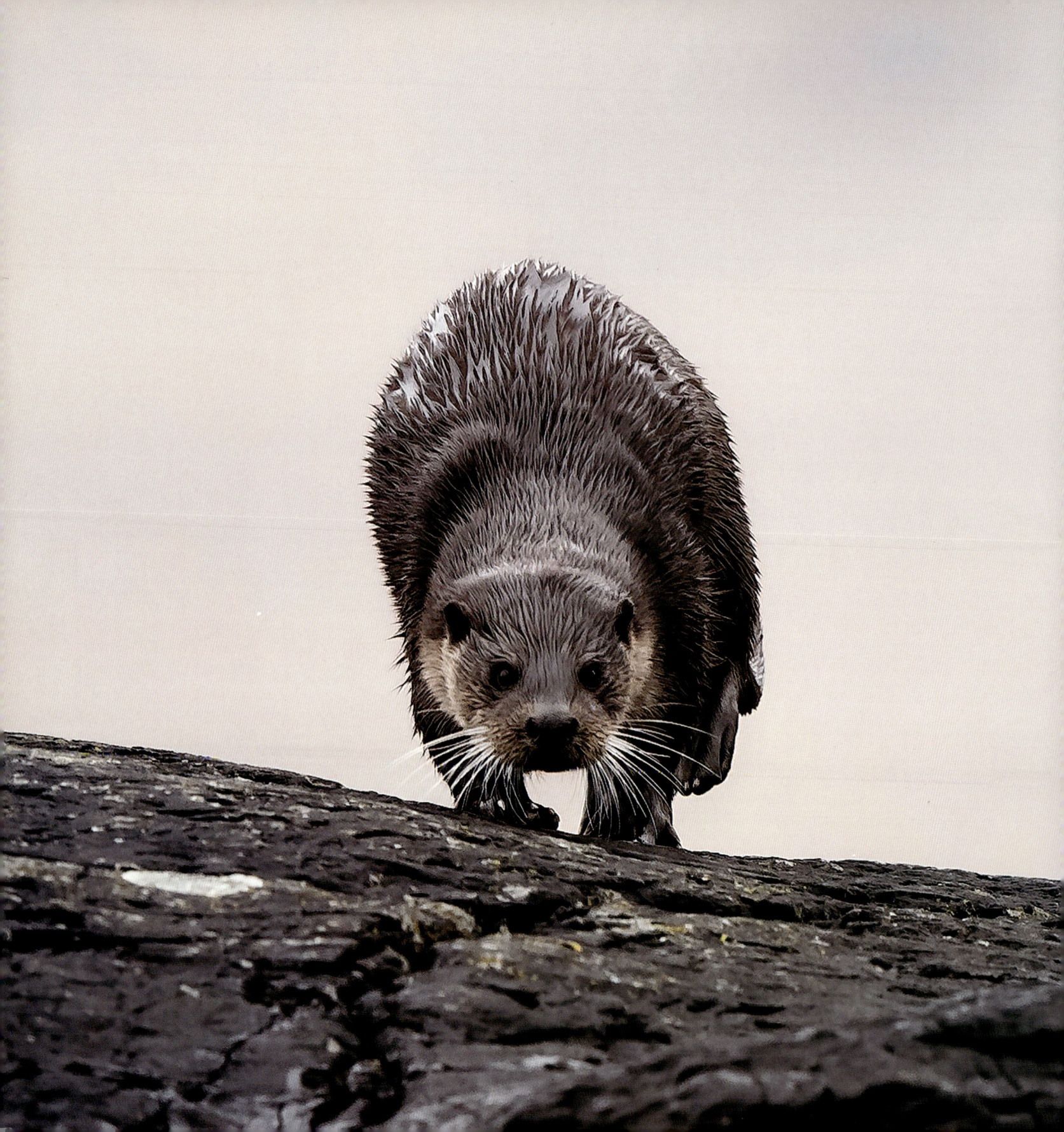

The Secret Life of the
OTTER

Andy Howard

Foreword: Gordon Buchanan

First published in Great Britain by
Sandstone Press Ltd
Suite One, Willow House
Stoneyfield Business Park
Inverness
IV2 7PA
Scotland

www.sandstonepress.com

All rights reserved. No part of this publication may be reproduced, stored or transmitted in any form without the express written permission of the publisher.

Copyright © Andy Howard 2021
Foreword copyright © Gordon Buchanan 2020
Image copyrights © Andy Howard
Other images as ascribed
Editor: Robert Davidson

The moral right of Andy Howard to be recognised as the author of this work has been asserted in accordance with the Copyright, Designs and Patents Act 1988.

ISBN: 978-1-913207-41-0

Jacket and book design by Raspberry Creative Type, Edinburgh
Printed in China by Imago

Acknowledgements

This book exists only because my darling wife, Lyndsey, puts up with me disappearing for weeks to 'go play with the otters', and holds the fort with such competence in my absence. I am endlessly grateful both to her and for her. Thanks also go to my friends, Sharon and John Moncrieff (Creiffy), for introducing me to the delights of Shetland and igniting my passion for this species and, more importantly, observing and photographing them. To Bob, my editor, for keeping me to deadline, for his honesty when I was heading in the wrong direction, and for his magic way with the written word. Most of all, I would like to thank the otters for so many wonderful encounters, for opening the door to their secret world of 'predictably unpredictable' behaviour and making me both laugh and cry. My heart will always speed up at sight of an otter in the wild.

The Secret Life of the Otter is dedicated to you, my dearest Mum (Marjorie), for everything you have done for me, for your love and devotion which has never faltered.

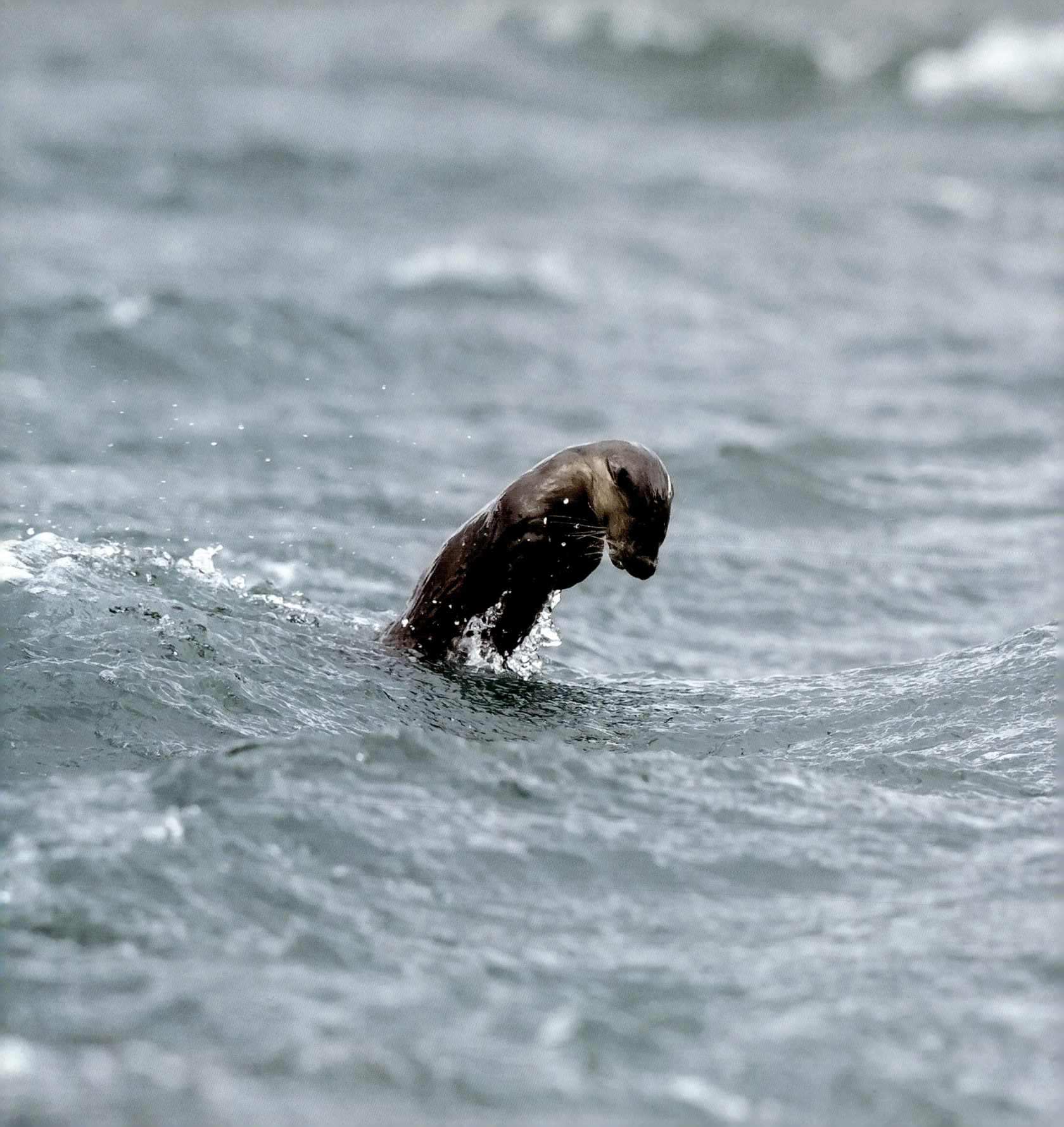

Contents

Acknowledgements and Dedication — i
Foreword by Gordon Buchanan — v

Introduction — 1
Beginnings and Endings — 7
Predictably Unpredictable — 37
A Room of One's Own — 69
At the Intertidal Café — 99
Mother Nature — 131
The Sea Otters of Vancouver Island — 163
CODA: Close to Home — 193

Appendix: How to photograph otters — 196

Foreword

Until the age of seventeen, my experience of the world's wild creatures was limited to those that lived close by. However, I was raised on the Isle of Mull, and its wildlife is magnificent.

Thirty years later I can agree that, from the high Arctic to the tip of South America, I have had more than my fair share of encounters with the furred and the feathered, the creepers and crawlers, animals that scamper and others that sprint but, still, have not seen it all. Our world is wondrous, and a single lifetime can only scratch the surface, but I can say this. Of the six thousand or so species of mammal there are only a few with that 'special something', creatures whose unique appeal defies explanation and, of those, one in particular has held a lifelong fascination for me: the otter.

My first encounter was as a boy one chilly Christmas Eve in the river that runs through Tobermory; my most recent on a summer's night on the rugged shores of Mull's west coast. Endearing and elusive, otters always delight and are impossible not to love. My elation on seeing one has never waned. However, writing now, I experience a different kind of exhilaration and that is my excitement for you, the reader.

As you study the cover of this book with anticipation, and leaf through its first pages, prepare to be spellbound. Let this foreword act as a somewhat inadequate drum roll for a breathtakingly beautiful experience, the most delightful and definitive portrait to date of this wonderful animal.

Behind it lies a less obvious story of dedication, knowledge, and passion, because the author, Andy Howard, is himself a rare creature. Not only an outstanding photographer he is also a skilled naturalist with unrivalled fieldcraft who has poured his commitment, understanding and respect into every image and paragraph. What Andy sees through his lens is not just the otter but the hundred and one micro details that perfectly merge in a moment to be treasured for a lifetime.

There are those who look and those who see, and I can only imagine the many weeks of searches and frustrations, the early mornings and cold, wet nights that each sighting has demanded.

On the final page, he offers some very sound advice: 'Take in your surroundings as no photograph or video will ever capture the essence of what you are experiencing'. Here, at the very beginning of the book, let me offer some equally sound advice of my own. Among these pages is the generous gift of lived experience, including moments of intimacy, revelation and joy, as Andy Howard gradually reveals the secret life of the otter. Absorb, as deeply as you can, every visual image and written word of this marvellous portrayal. It will prove to be a rare experience and will live with you for many years.

Gordon Buchanan
Glasgow
November 2020

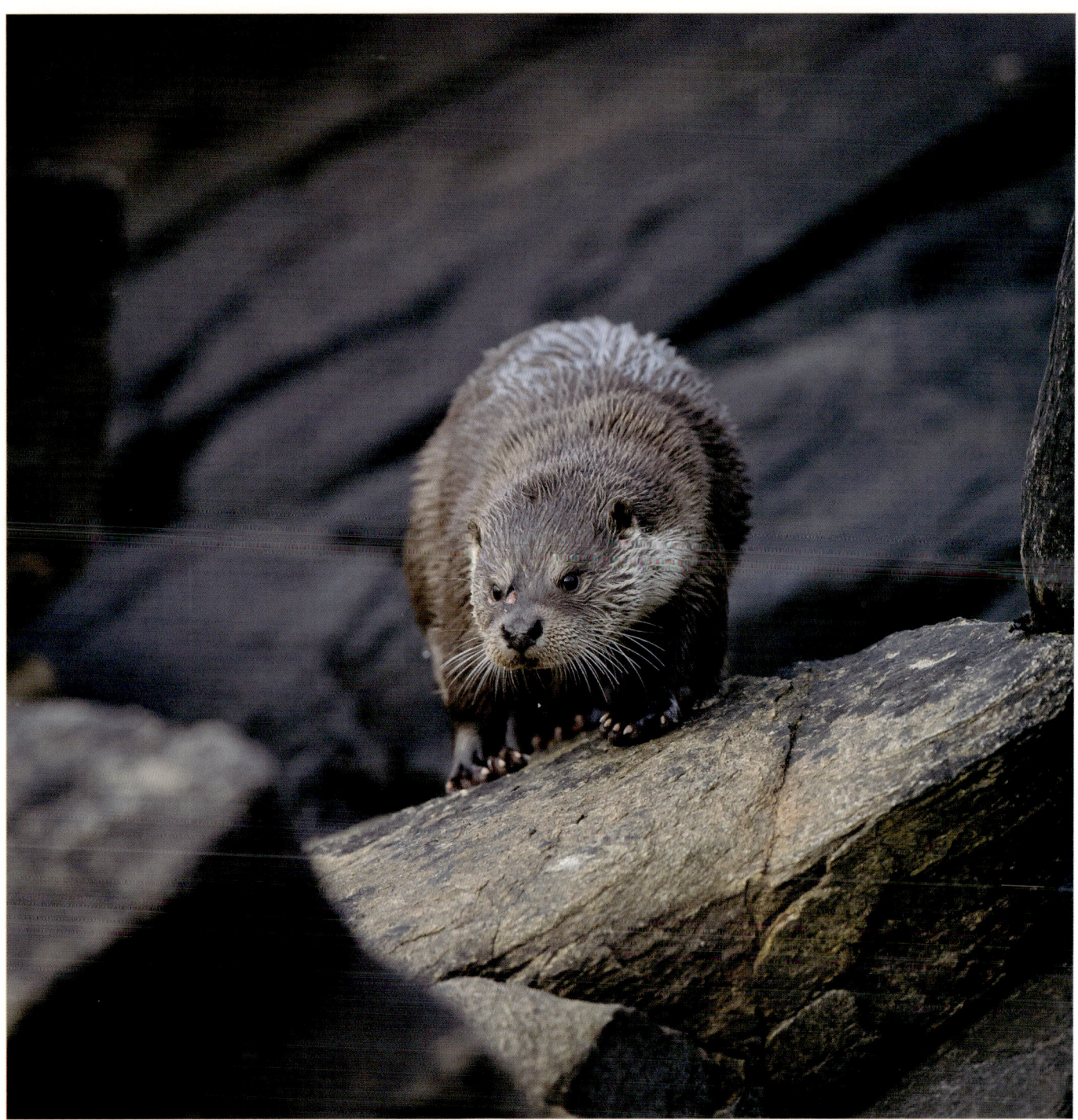

INTRODUCTION

One day towards the end of summer I found myself hunkered behind a drystone wall in the Hillswick Wildlife Sanctuary in Shetland. Beside me was one of the trustees, Jan Bevington, and we were looking at an odd arrangement she and her husband, Pete, had created in their garden by stretching a fishing net across poles over an old tin bathtub. A hose lay on the net so that water filled the bath which had, floating inside, a couple of mackerel. Patience was rewarded when a small face appeared in the bushes behind.

Max was an abandoned otter the sanctuary had been rehabilitating since he was no more than a few weeks old. Now grown into young adulthood he was close to full recovery. After checking that the coast was clear (Jan and I did not seem like threats) he made a scampering leap for the mackerel which he carried into his wooden hutch to consume. After this the fun began, when the fully fed Max came charging full tilt out of the hutch to leap onto the sloping side of the bath, go sliding along its floor and come flying up and off the other side. Under his shower of cold water he ran joyously in circles, jumped in the air and danced as if no one was watching. Obviously, he was well on the way to full health.

He was happy as a child and any human child present might have been tempted into the unwisdom of petting him and trying to make friends. Best not! In an earlier job I met one of Gavin Maxwell's assistants from his *Ring of Bright Water* days, Terry Nutkins, who had lost two fingers to an otter's snapping teeth. He carried his loss philosophically, but the lesson is obvious. For all its attractions and human-like qualities the otter is a wild animal: intelligent and playful, but sharp toothed and quicker than any human hand can hope to be.

Jan and Pete would later reintroduce Max to the wild near the home of another friend where, in no time at all, a bitch otter became pregnant. We like to think that his

Otter on the rocks.

offspring are still spreading along the voe, and there is a special pleasure in looking out for cubs in the area.

I came to Shetland relatively late, after social media correspondence with a talented local photographer called John Moncrieff. Annual visits followed, with my naturalist's eye trained on all the islands' wildlife but especially the otters, which are not easy to find as their natural camouflage is almost perfect among the rocks and kelp of the coast.

Shetland is a land of extremes, an archipelago located almost midway between Scotland and Norway, shaped over millennia by a continuous battering of weather and waves from which there is little shelter. No part of the coast is remotely straight and its long, ragged inlets, or voes, provide excellent inshore fishing for not only man but also a range of predators varying in size from the otters themselves to the mighty orca.

Two days of storms followed my visit to the sanctuary, but the third dawned bright with a stiff breeze dancing across the voe and the sun dappling dark, cobalt blue waves. These were near perfect photography conditions, but they made locating the otters even harder, as the swell, the crashing of the waves, and eyes that watered in the biting wind made steady observation difficult. Low lying islands make for large skies and only time can hone the instincts necessary to locate the animals beneath them.

Looking out from my cranny among the rocks, searching across seaweed and boulders for anywhere that looked faintly otterish, I found no joy until a gannet turned abruptly in the air to make a bullet-like dive into the water, a plume of brilliant white spray exploding upwards where it entered. Emerald green bubbles meant I could follow its progress until it surfaced and took off again in a single speedy, graceful manoeuvre.

Following the line of its swim, about fifty metres away on a rocky peninsula, my attention was taken by a piece of kelp blowing in the wind. Or was it something else? I lifted my binoculars and scanned the rocks for movement, eventually to spot the unmistakable chocolate colour of a wet otter pelt. Were my eyes playing tricks? Suddenly it was gone, and I couldn't locate it again. With a view to moving on, I gathered my things, but a flash of gold in the water stopped me. It was my otter. My experience had indeed prevailed over its camouflage.

Otter prints in mud.

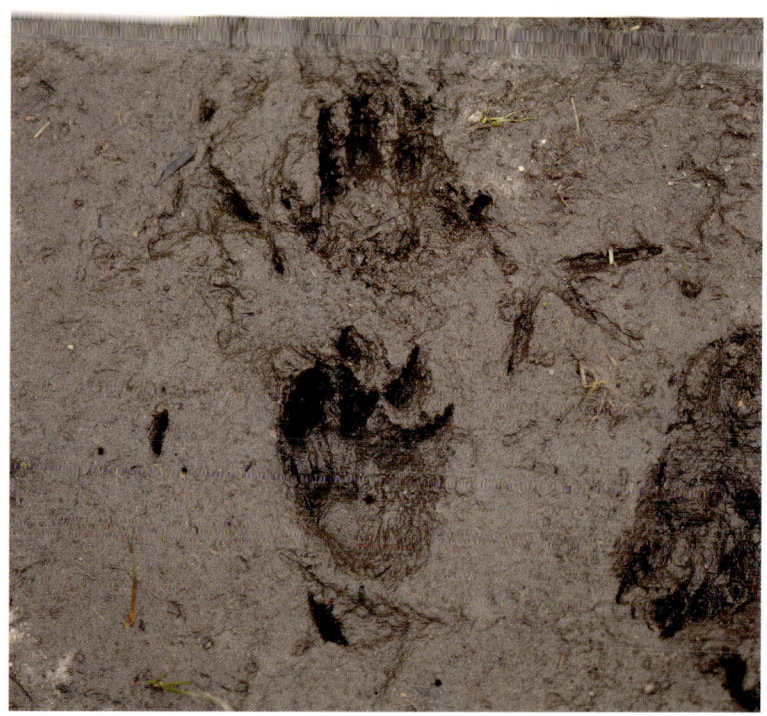

Each time it resurfaced its head shone bright beneath the sun but was immediately lost in the crashing waves. After a while I stood up cautiously, only to see it on the shingle close by, finishing off a medium-sized fish. Otter behaviour is unpredictable, as this one was about to prove when it dropped the remains of its fish and walked towards me. Fortunately, the wind was blowing my scent in the other direction. I ducked down for another few minutes before slowly lifting my head level with the bank… to find myself looking into its eyes. Startled, it bolted back into the voe to tread water and stare resentfully in my direction.

Although this experience was a sort of a privilege, it felt like failure on my part. The otter had come to me, not the other way around, and I had missed my shot. From afar I watched as it continued along the shore, no doubt to its holt, wherever that might be, and remembered my first, similar, experience on the inner Hebridean Isle of Mull, and how I first fell in love with these animals.

My early life was in many ways fortunate and, although it did not seem so at the time, much of it pointed towards my present career. My aunt owned a house on the west coast of the island and I spent my summer holidays there. Month on month, year after year, untroubled by the worldly cares of adults, my

Paws for thought.

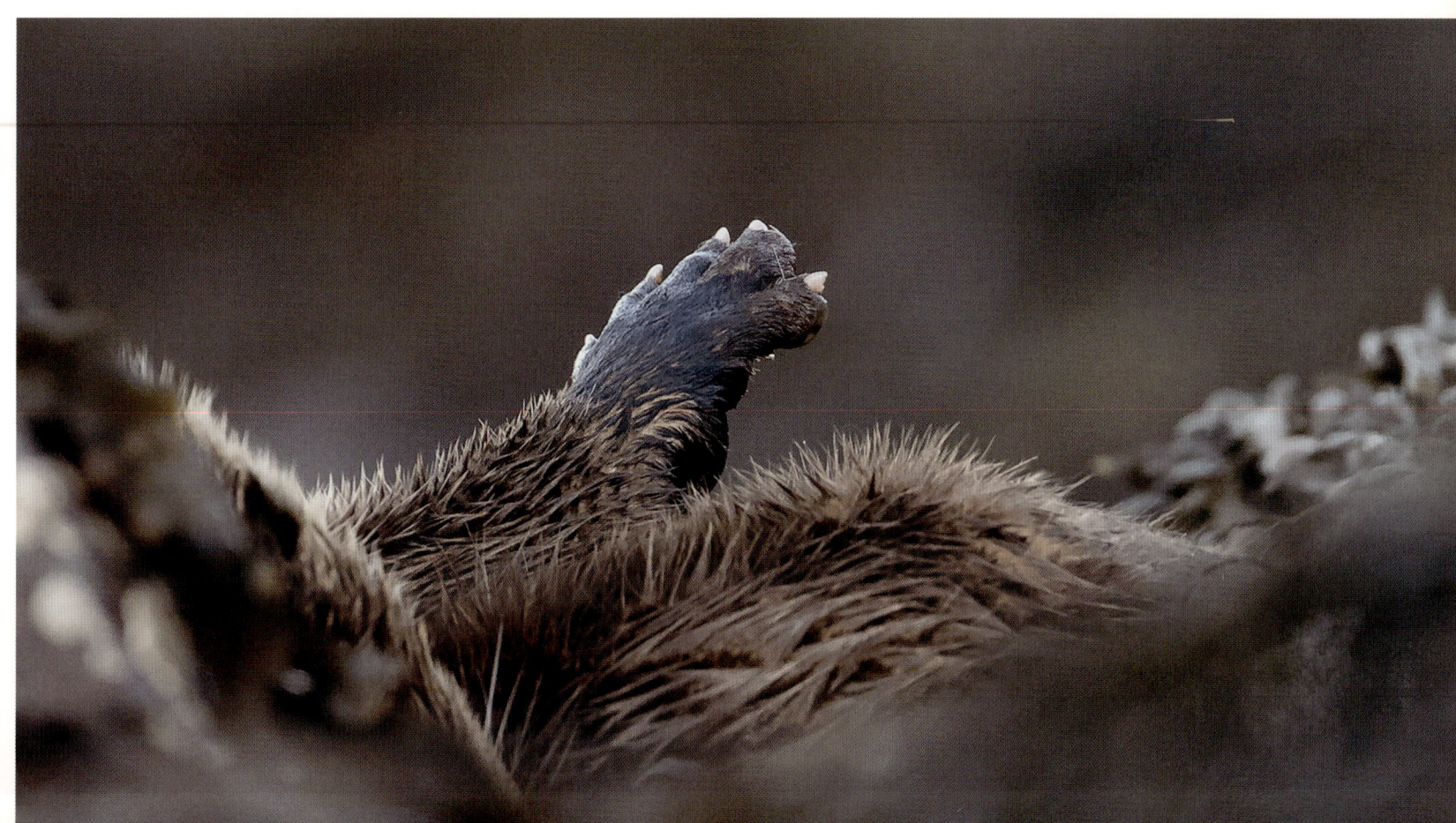

brother, cousins, and I ran wild and lived an almost feral existence. Outside from dawn to dusk my skin was toughened by weather and constant activity, and my spirit sensitised by closeness to nature: by deer on the skyline, golden eagles riding the wind, dolphins in the Sound, and otters along the coast.

The boy who could afford to take it all for granted, and consequently watched with too little wonder, now haunts the mountains and the coast not only with a camera but also with ever-increasing amazement.

I photograph many animals but, in countless ways, it is the otters that pose the greatest challenges. Their incredible shyness combined with hyper-aware senses and natural camouflage makes them successful survivors but elusive in the extreme. I am always aware though, that when the environment is 'ottery', they are likely to be present and the question is precisely how to locate them. After that, how to capture their images.

Often it is a waiting game, and for me there is little more satisfying than being close to an otter that has no notion of my presence, which allows for intimate observation, as on one morning when I spotted a disturbance among the seaweed close to shore. At first I thought it was an otter with a dog fish, or a large eel, but when I got my binoculars focused I found that I had accidentally struck gold: a pair of otters was mating in the shallows. With camera and tripod quickly erected I got busy on both stills and video, working quickly and silently. The action proceeded for about thirty minutes until the female decided enough is enough and sent her lover packing.

Otters are fascinating in both the details of their life and their character. Born killers, the mothers are loving to their offspring, so tender their emotions can seem almost human. Their liquid movement in water is as balletic as it is purposeful but their movement on land, while quick and effective, is so different it could belong to another species.

They do comic things, playing with each other, with pieces of seaweed, fish, crabs. Their antics and mischievous ways never fail to bring a smile to my face, and when I am closely observing them at rest… is that a form of kinship I feel? Like the otter I am endlessly curious and live a restless life. Like the otter I am completely focused on my purpose. Like the otter I am dead to the world when I settle for the night and, often, when I watch them sleeping, my breathing will co-ordinate with theirs until I too start to drift.

A real challenge to locate, as some of the following images will demonstrate, otters are all too easy to misplace again. See one tuck itself behind a rock? You cautiously approach to find it gone, vanished. Experience tells me though, sit for a while and it will probably re-appear. They are most likely to detect a human presence by their sense of smell, second most by hearing. They have relatively poor eyesight but will not miss the outline of a human against the sky even from distance. Be still though, wear camouflage and get amongst the rocks and an otter might walk right up to you, blissfully unaware of your presence. One wrong step, a crunch of boot on gravel, and it is game over.

My first otter experience was during that feral boyhood. The family was enjoying a barbecue beside the Sound of Iona when I became aware of movement at the outermost limit of my peripheral vision. An otter emerged from the waves and made its calm way across a beach of white sand. I followed it with my eyes until, all at once, it turned its head and looked back at me. There was a moment of immeasurable, no doubt short, duration when I had the sense of a questing mind that,

although not like mine was no less capable in its own way. An intelligence evolved to assess and act, that was quick and fierce but seasoned by experience. One that knew no compromise and could not be tamed. A mind that knew when to strike and when to swim, and understood that some things could simply be ignored, like me. Frequently through my working life, I have had this same eye to eye experience with otters and it has never become less disconcerting.

Most of the images in this book were captured in Shetland and Mull, with a whole section given over to the sea otters of Vancouver Island in Canada. I will not be more explicit on locations, not wishing to encourage additional, unnecessary traffic. Experiences such as mine are to be had in many places around Scotland, but I urge respect for location, animals, and the human population. Be sure to leave no trace.

Very often the encounter is as much about 'being' as seeing or doing, about the scenery, the ebb and flow of the tides, being lost to yourself. I often tell clients about the acceleration of time in the presence of otters. Minutes feel like seconds, hours like minutes. I hardly notice the tide creeping in until it laps at my feet. This book is not filled with science, only anecdotes, observations, and pictures from many thousands of hours in their company. I would like the reader to join me in my growing sense of wonder. The details in the images matter, as do the nuances of otter behaviour, but their animal beauty is capable of something more: of taking us out of ourselves and into nature, of creating a sort of bridge. This book is more than a record of my experiences. It is the celebration of a species.

Otters crossing.

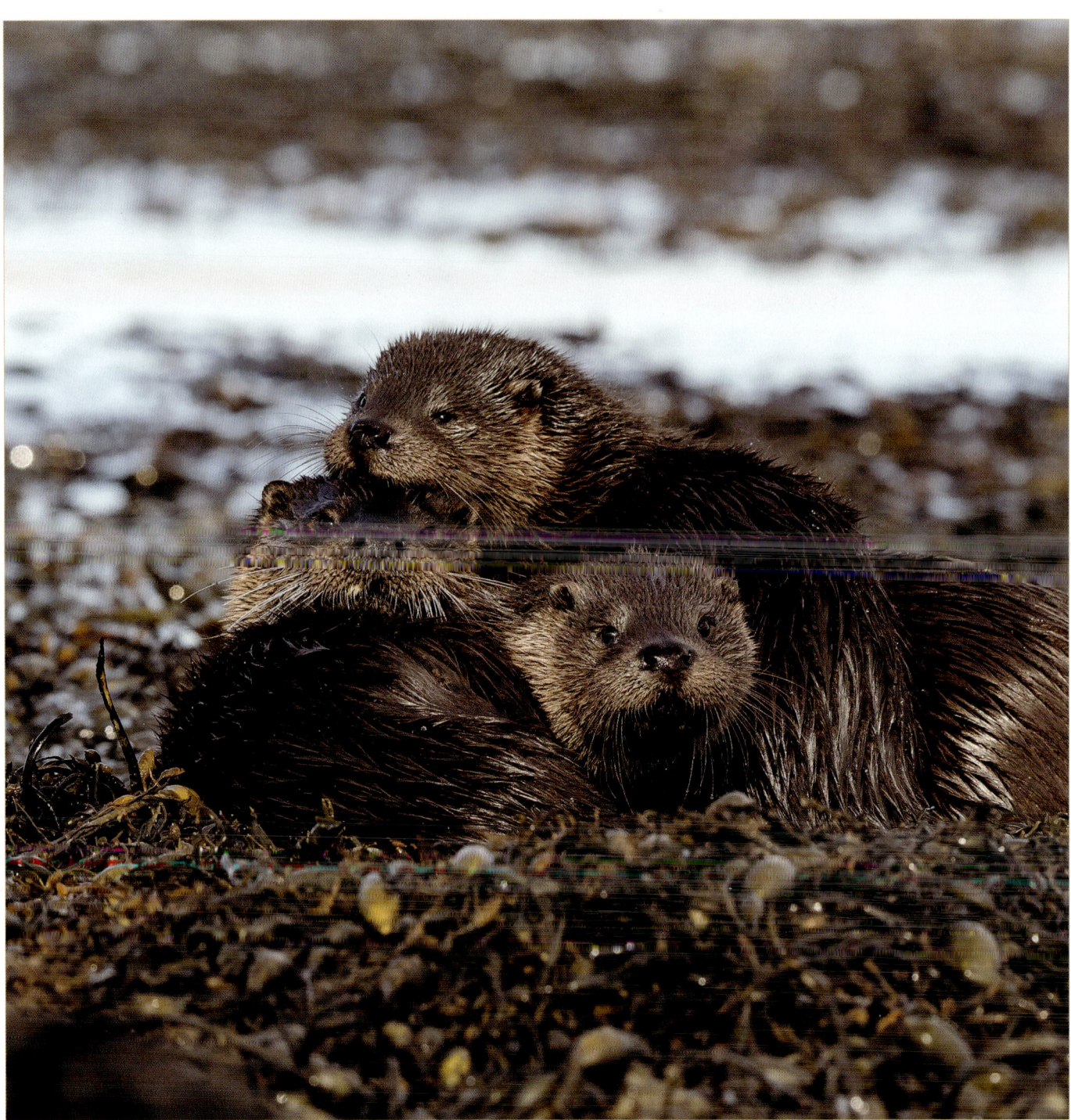

BEGINNINGS AND ENDINGS

One evening, when the light was near its lowest, I heard an awful shrieking from along the coast. It was certainly an otter, but its crying expressed fear, desperation and calamity. I made my way to the scene as speedily as the slippery boulders underfoot would allow. By now it was raining, the midges were out and conditions for photography were far from perfect. On my arrival at an established holt a bitch otter darted at break-neck speed into the water to turn and look back at the rocks, still shrieking pitifully. I was struggling to set up my tripod, all too aware of the fading light, when a dog otter appeared from the holt with what looked like a sausage in its mouth. It was, of course, one of the bitch's cubs, which the dog killed then and there, as it did the rest of the litter. He had taken over another otter's territory and was ensuring that his own genes would survive without rivals.

Beyond her terrible trauma, the bitch's body would respond by returning rapidly into heat, and the dog would be close at hand to impregnate her. I got no pictures, partly because of the light, partly because I was, myself, so upset.

The new cubs would be born into a world of wind and water. To protect them they will have their mother's love, for a time, and a pelt with ten times the density of a husky's. The likelihood of their surviving the five to ten years that are possible are slim and they will live with almost unassuageable hunger. Unlike other aquatic mammals, such as seals, they have little fat on their bodies and require a constant supply of calories to feed their extraordinarily high metabolism. To survive they must be quick and determined, and they tend to go directly at what they want: moving rapidly, always hunting, consuming voraciously. Any protein they can grasp goes down their gullet.

I once watched a bitch devour two huge fish over a period of thirty minutes. The first must have weighed

Cub sandwich.

about three pounds and the second looked even larger. The unpacked volume of all this food was easily bigger than the otter herself, so it follows that everything inside the animal is under high pressure, including internal organs. Evidence for this is in the volume of their spraint and the force with which it is ejected. After eating she slept under a rock for four hours, which I know because I sat and watched.

Litters will number up to five cubs, but only two or three are likely to make it out of the holt, even though their mothers raise them with loving care. This they do without male assistance as the father may have several litters spread across his territory and his mind set on acquiring more. The dogs spend virtually all their time on patrol, moving from one end of the territory to the other, sometimes on the rocks, more often swimming along the shoreline.

The treasure they guard is their genetic legacy. Their enemies, other dogs. Fights are savage. Pelts are ripped and flesh is torn, and infections resulting from bites are among the most common causes of otter mortality.

Although he presents an anthropomorphically unsympathetic figure when it comes to family, the dog lives a tough and lonely life. After twelve to eighteen months of loving attention he has been chased off by a mother experiencing the hormone surge that will lead to her next litter. He has become a wanderer, seeking territory and mates of his own, and never again will he know peace of mind.

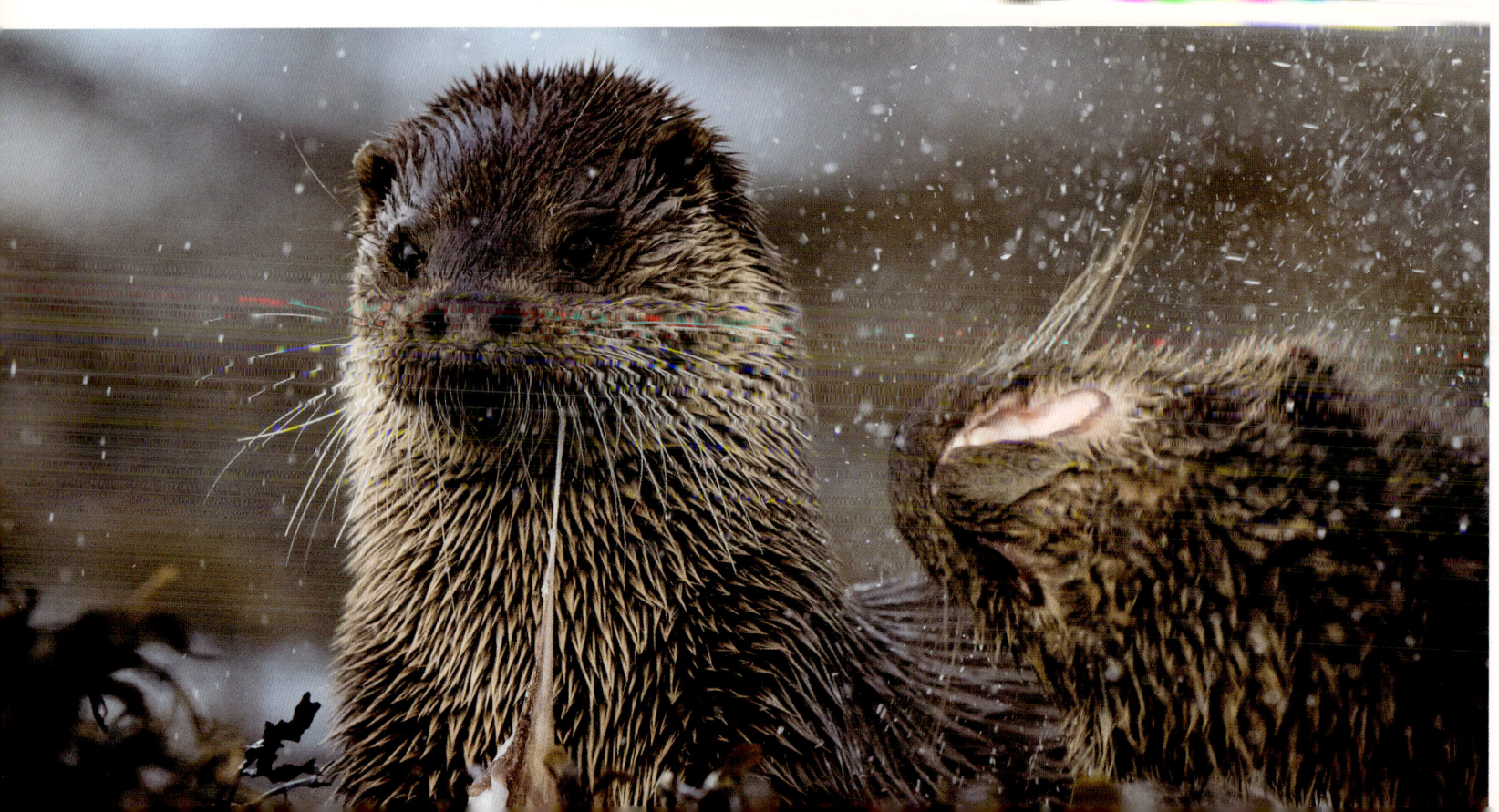

Mother and cub.

On the other hand, the bitches often remain close to home, to raise cubs using the same holts as their mothers. Theirs is a more familial existence, and I have often seen two generations playing together. Most memorably, while watching a mother with two boisterous cubs, I noticed a second female making her way towards the family, closely followed by another slightly larger cub. No animosity was displayed, so I assumed they were related. Soon, mother and daughter were fishing together while the older cub entertained its two, smaller half-siblings. I was in orbit!

Otter life is hard, but more survive than perish, or survive for long enough. Their competitive/co-operative system works, and now otters can be found in every county in Britain, which speaks well of the great post-industrial cleaning of our rivers, lochs, and coasts. It also speaks well of the conservation movement since otters received legal protection in 1978. Until then they could be, and were, slaughtered with impunity. Remaining threats include uncontrolled dogs, drowning in crab or lobster creels, and illegal persecution. They have no road sense and it is a sadness to most people when they see a dead otter by the side of the road. We humans also have as much primal instinct towards kindness as killing.

While working on a salmon farm as a youngster, I was horrified to hear talk of otter 'control'. This highly intelligent and adaptable creature will take food where it can, up to and beyond the point of nuisance, but accommodation must be made if we wish to pass a healthy existence on to our children. This, of course, applies to our relations with all other animals, the whole world being shared territory.

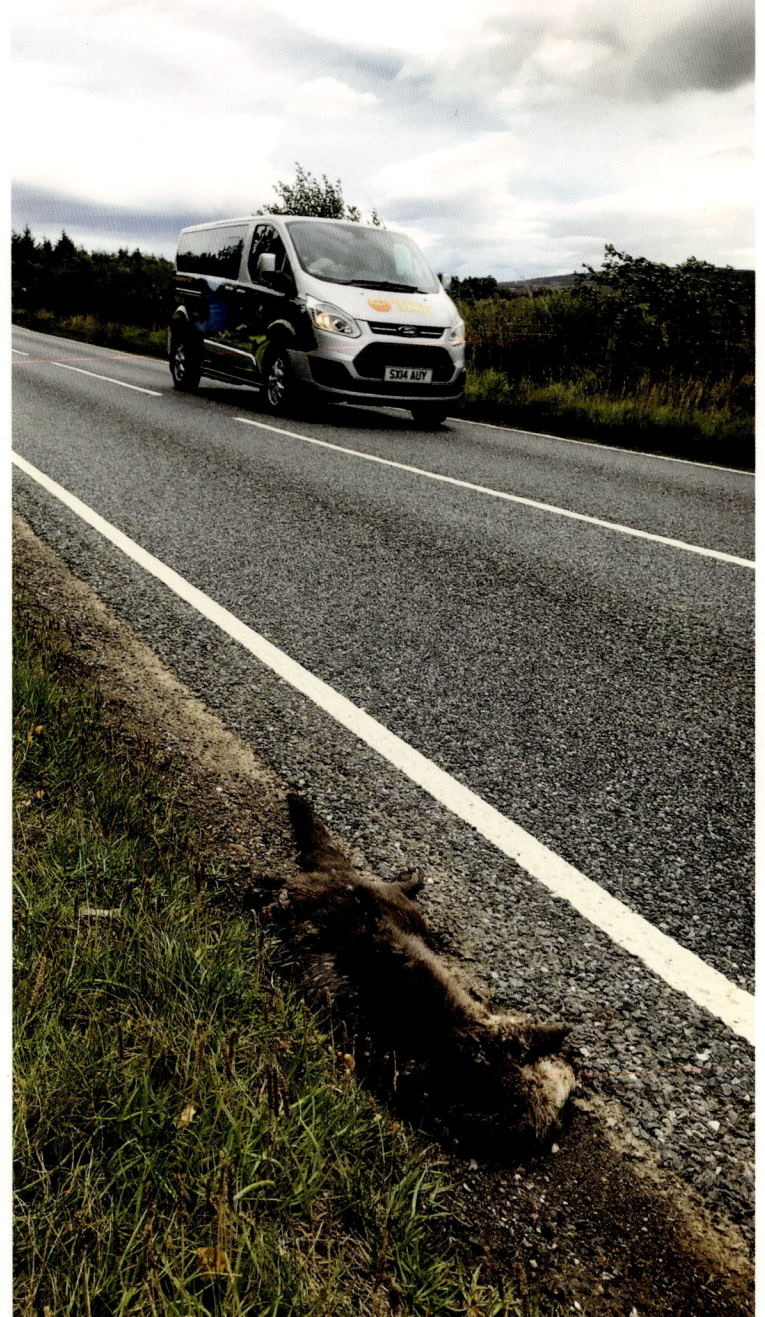

Road kill.

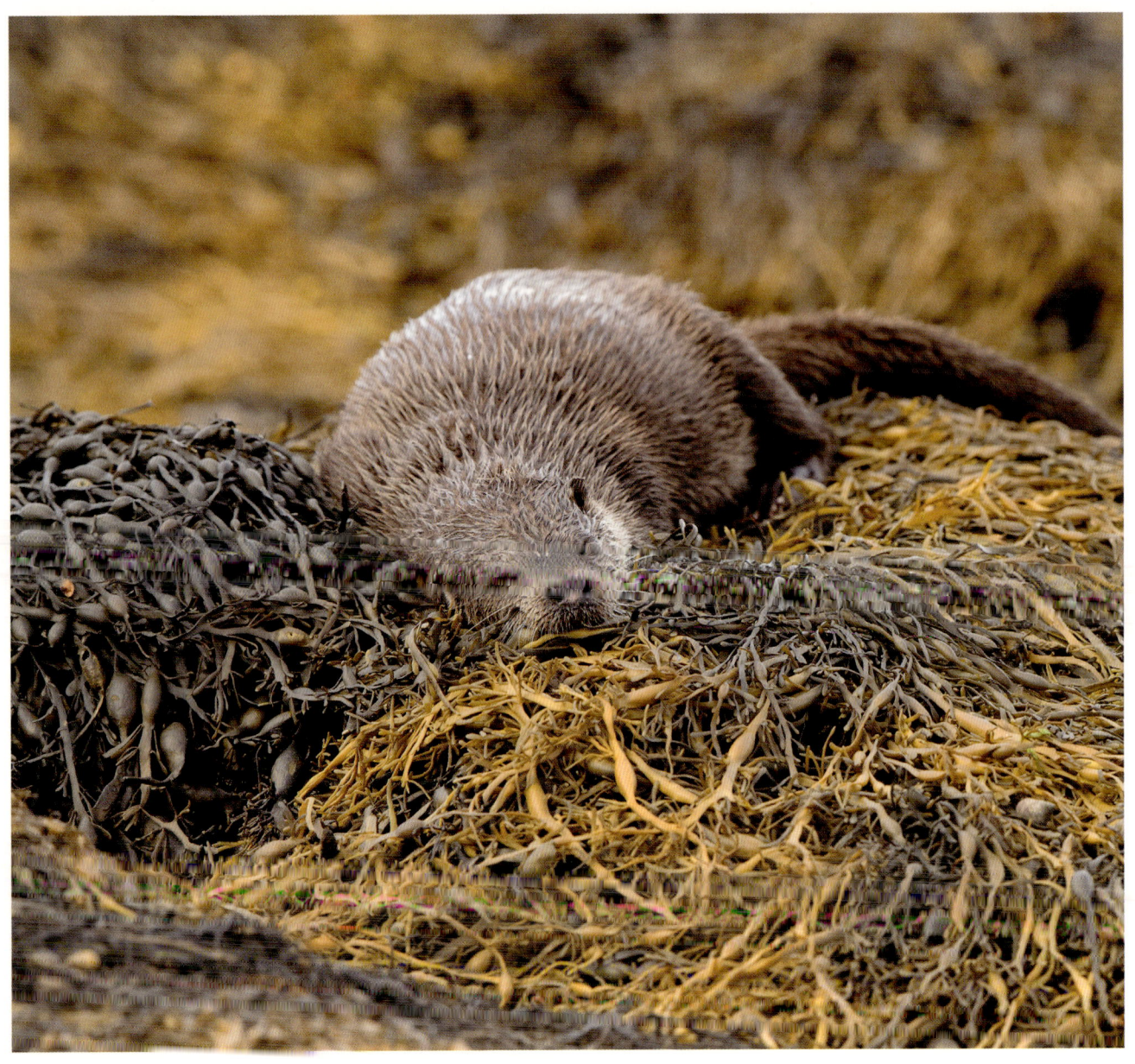

Above: Bed of bladder wrack
Right: Mother and cub embrace.

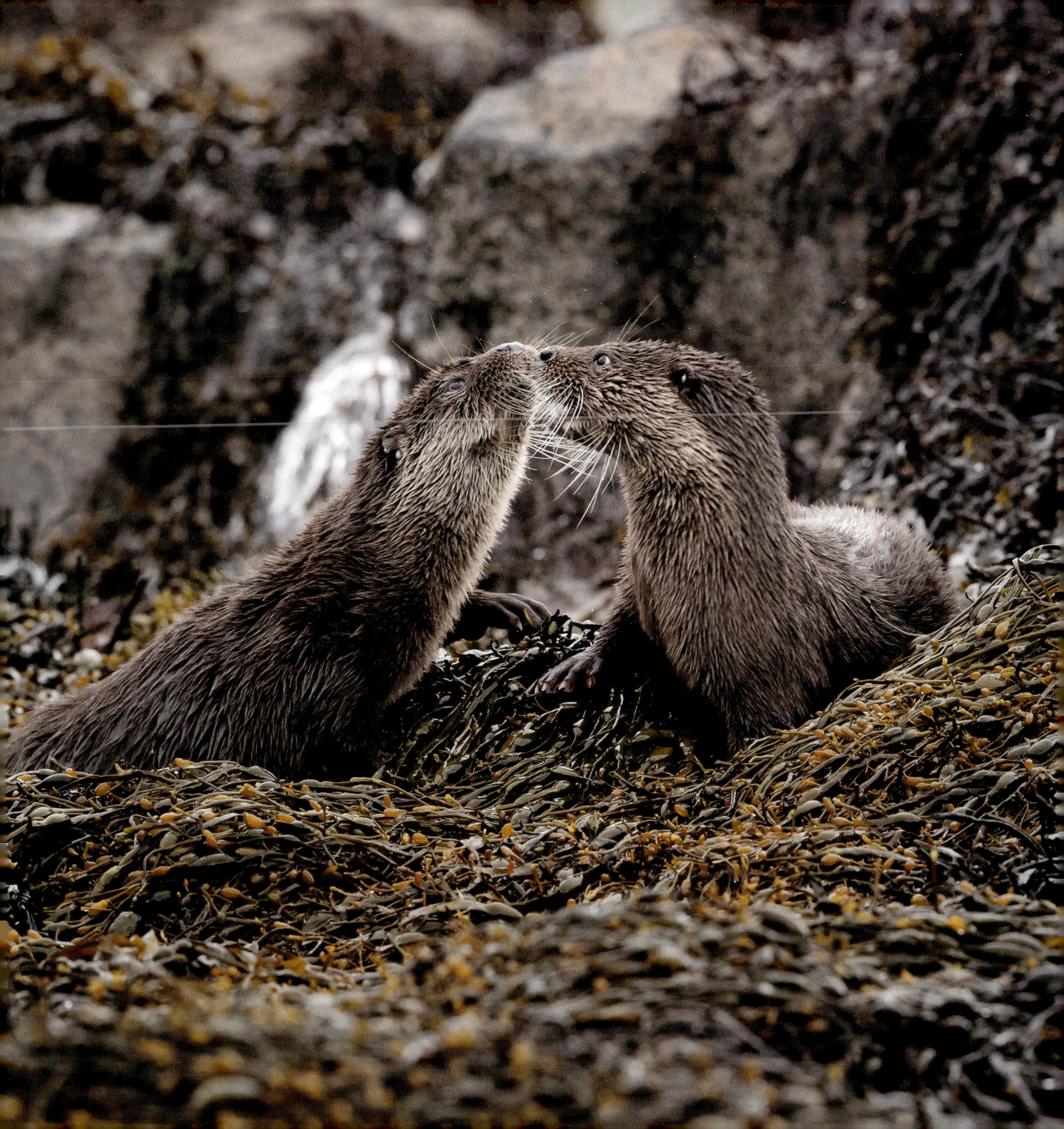

Dog otter patrol.

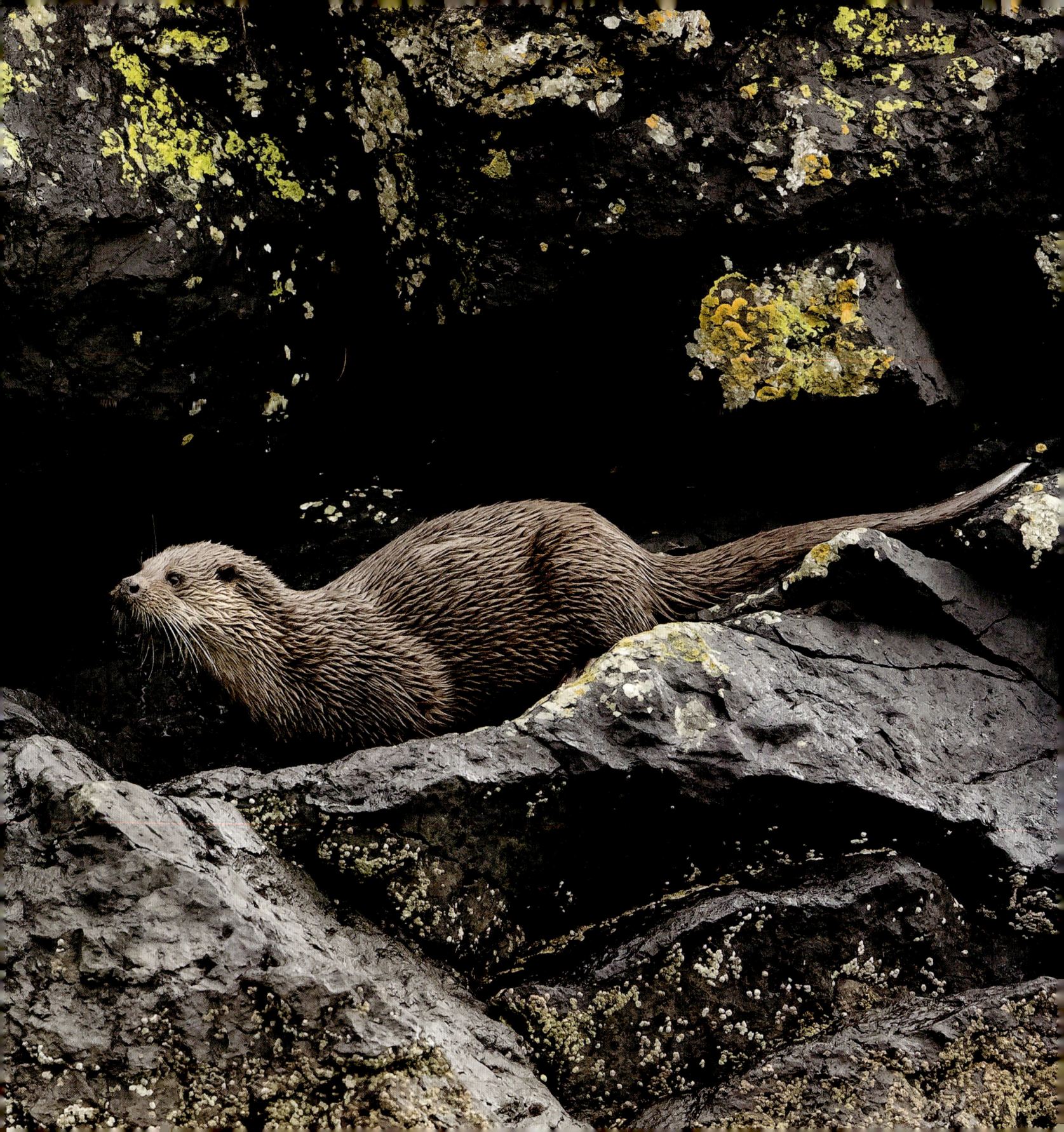

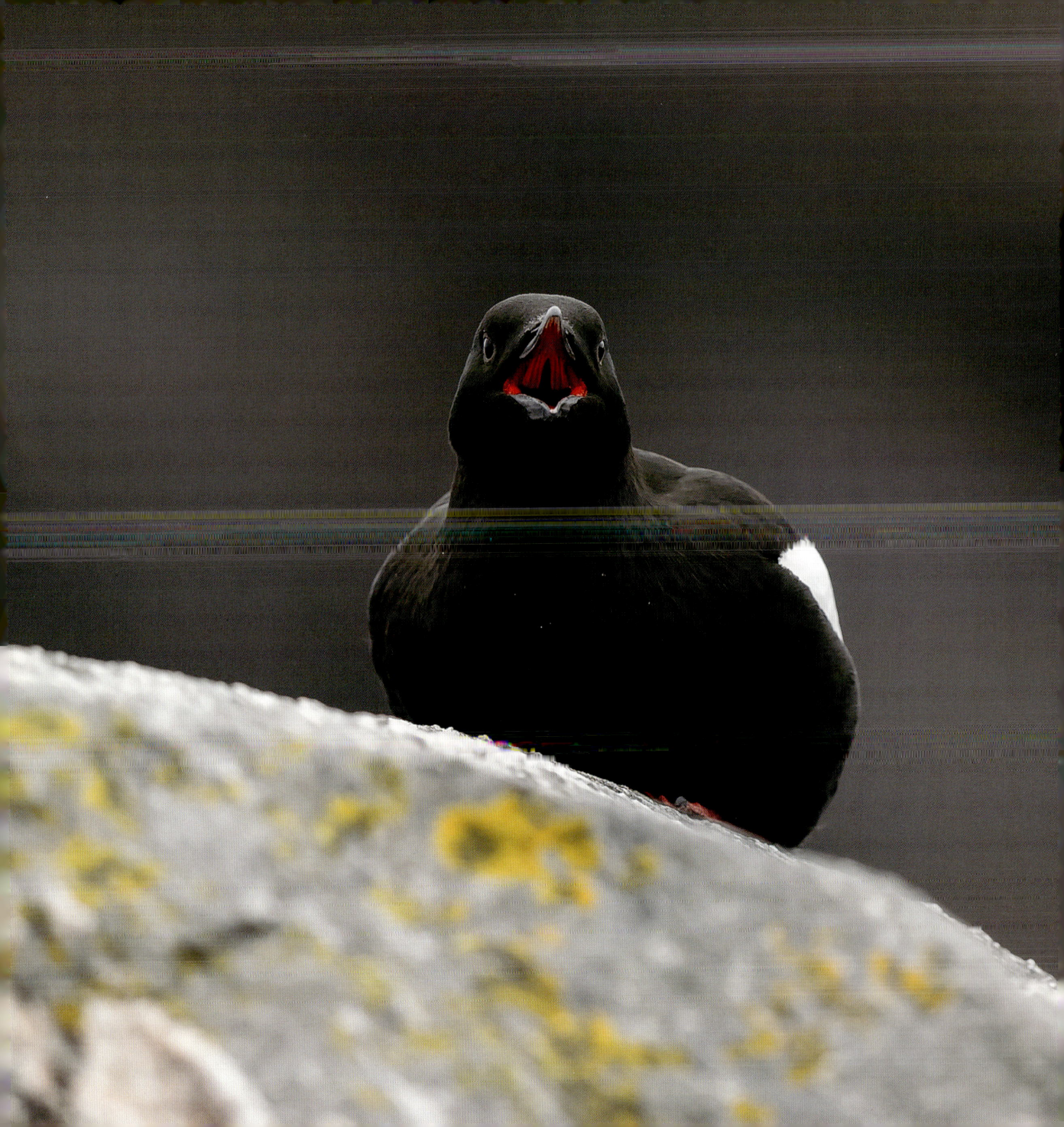

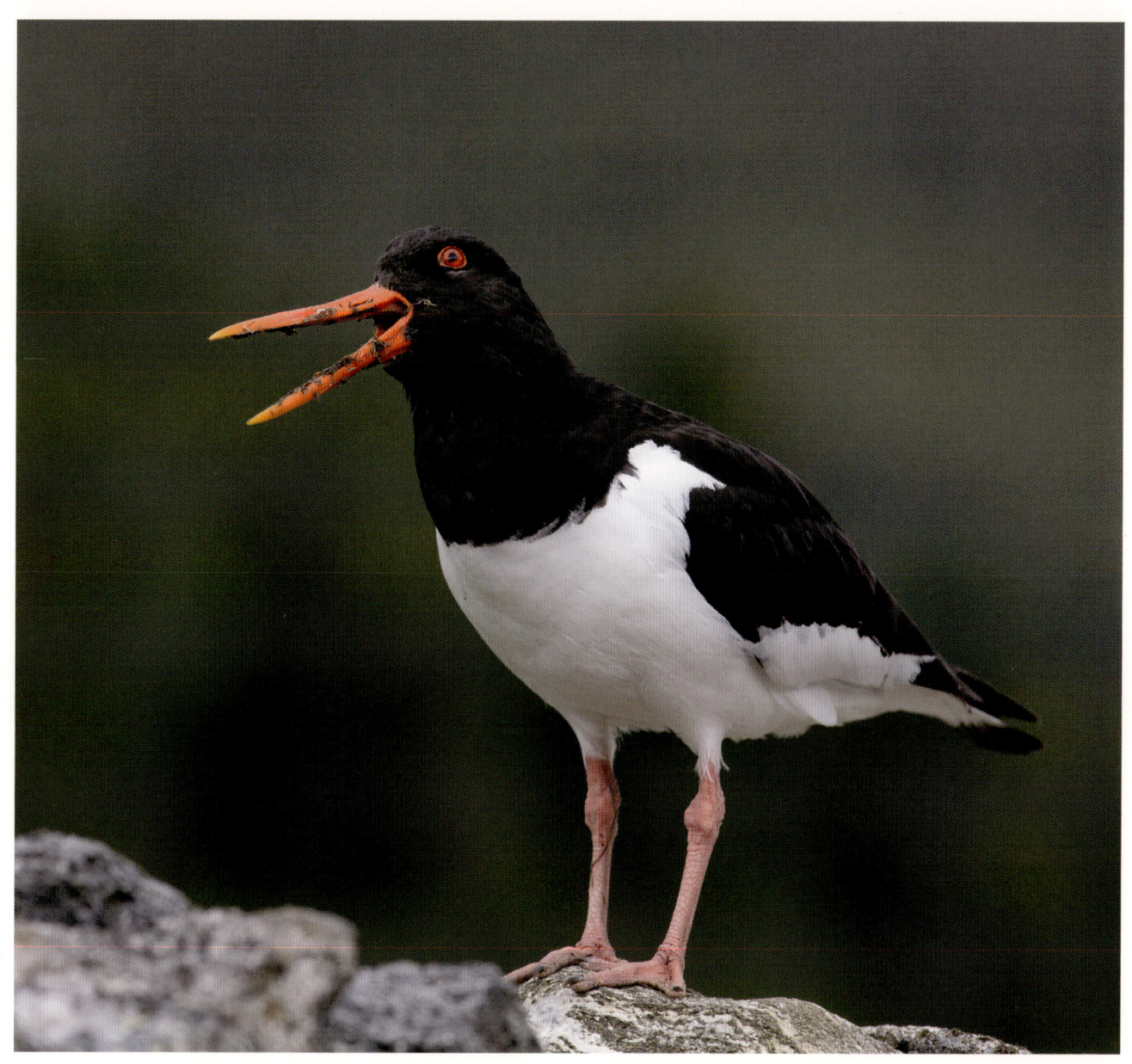

Left: Black guillimot.
Above: Oystercatcher.

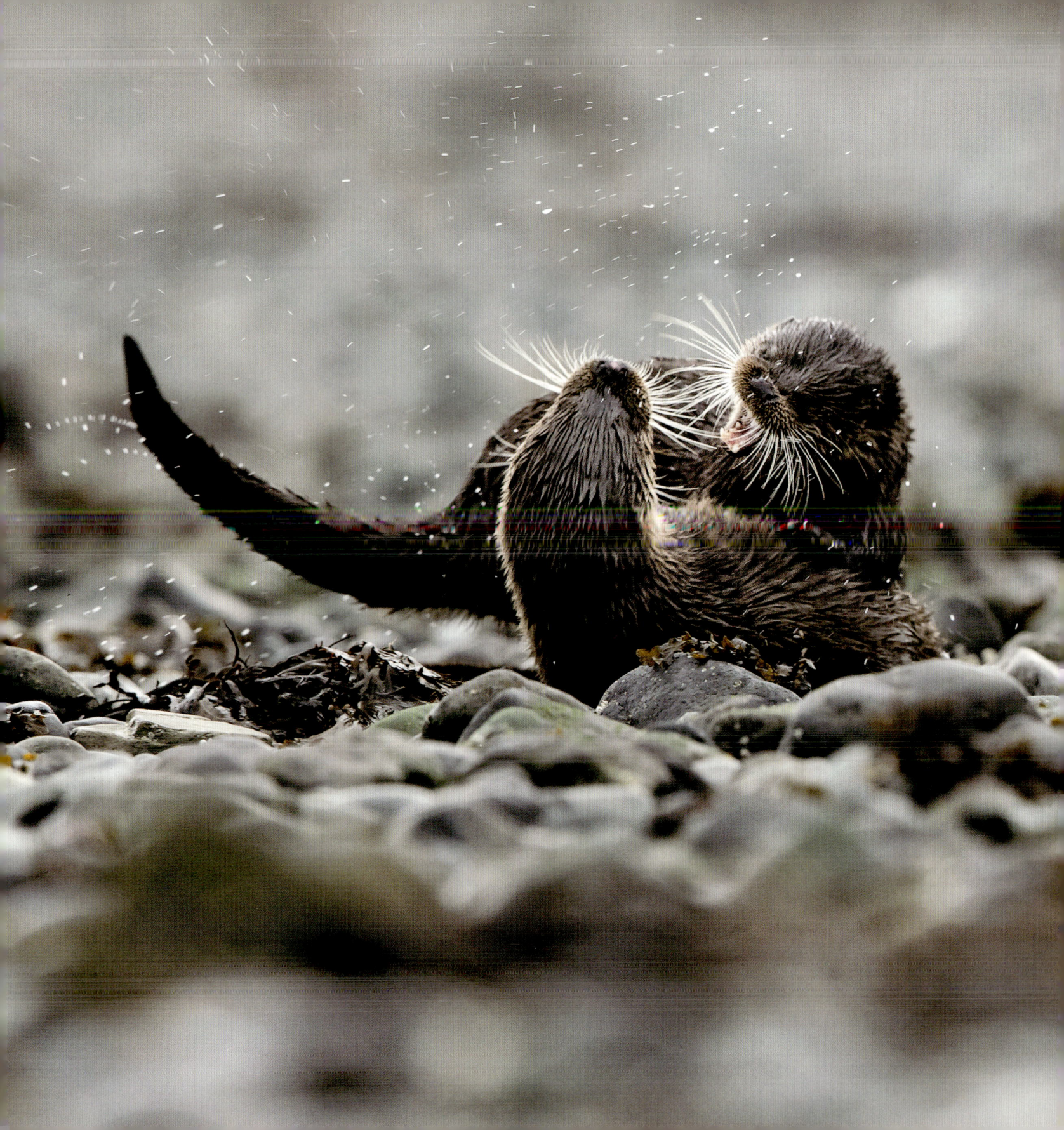

Field Note
Fight!

I've had many close encounters with otters but none as fierce as this. It started, as many do, as one came ashore with a fish. I was with a couple of clients so, careful not to spook the animal, we were extra cautious in our approach.

I was whispering the best camera setting to use when a second otter arrived. This was unexpected and, when the second otter approached the first, all hell broke loose. As they chased each other up and down the beach, I hastily barked instructions on more setting changes: high shutter speeds to freeze the action.

The otters really went at each other until one threw in the towel and retreated hastily into the water. Both of my clients were wide-eyed and breathing deeply. 'Please tell me you got that?' I pleaded. They had, but this is the best of my own shots.

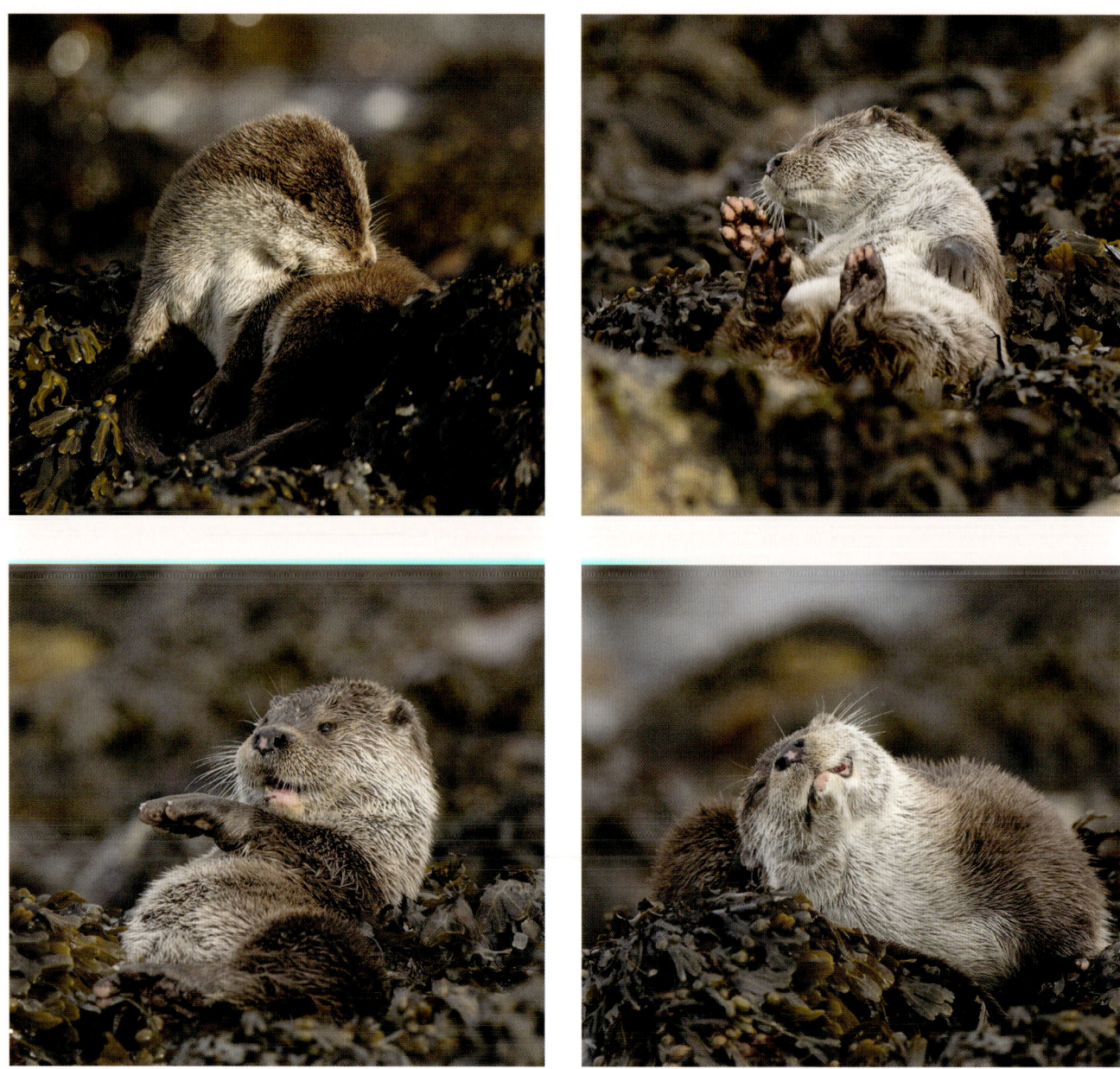

Above: Pelt maintenance.

Right: Drinking from a fresh water spring.

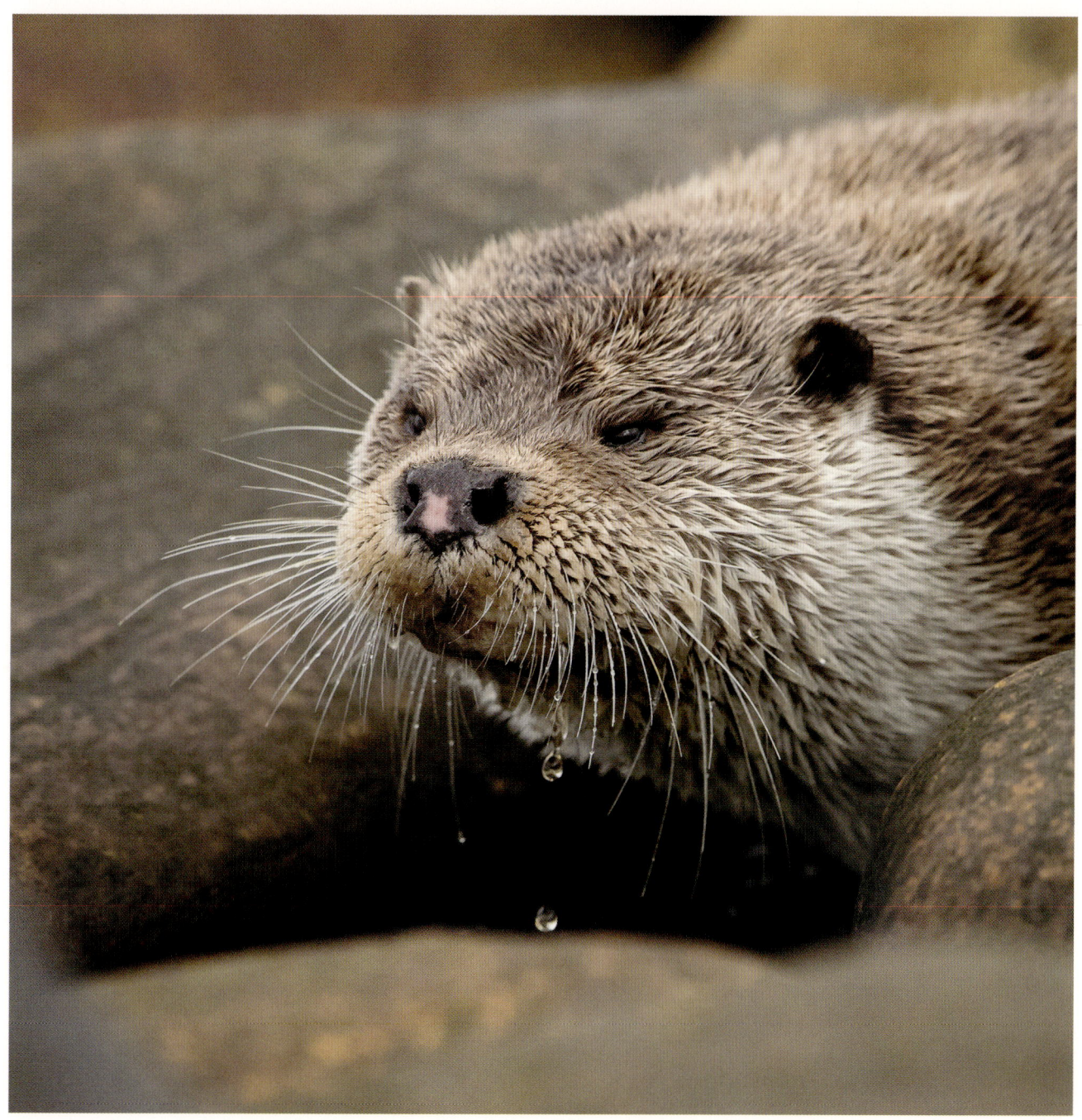

Mother and cub at rest.

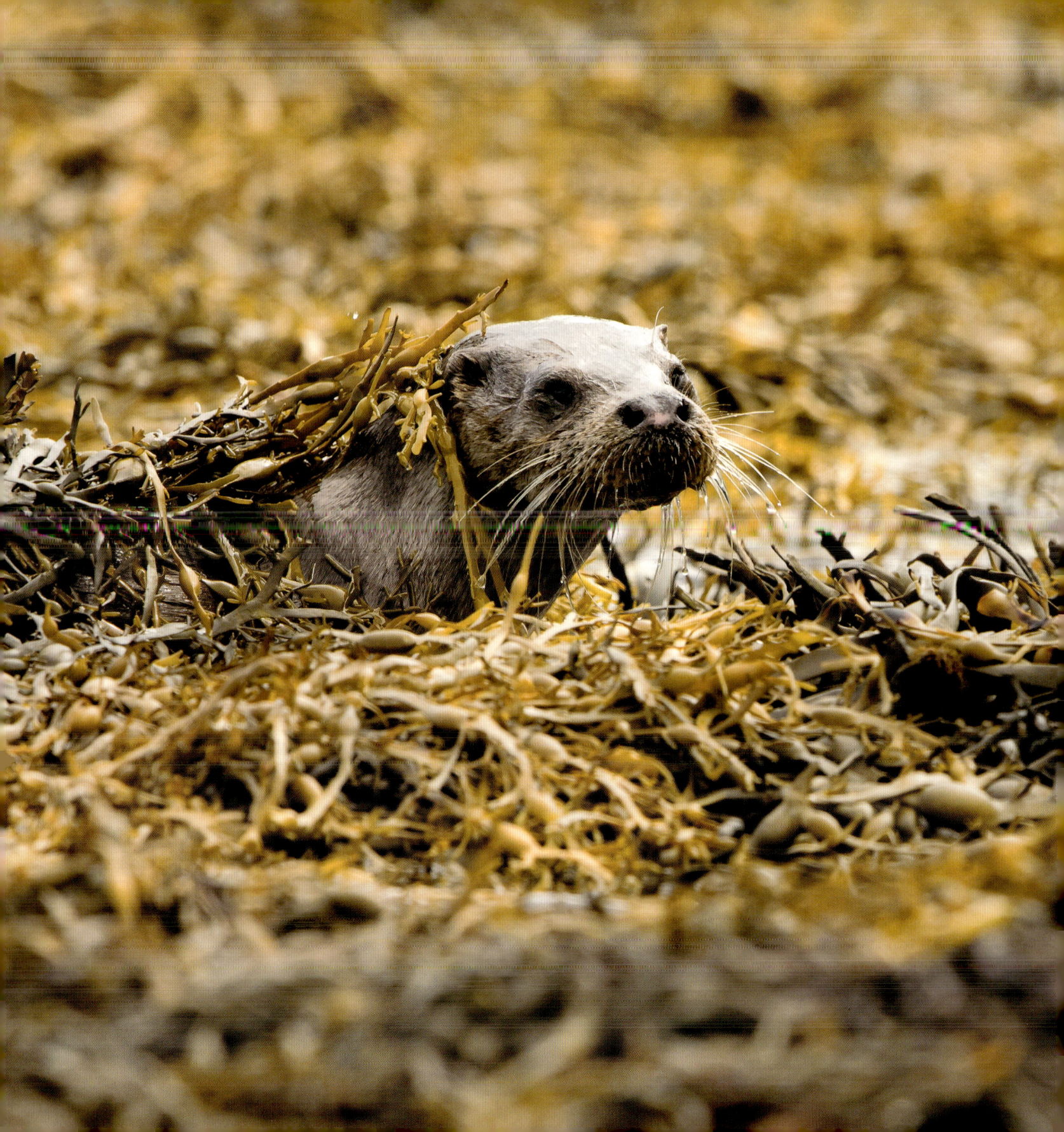

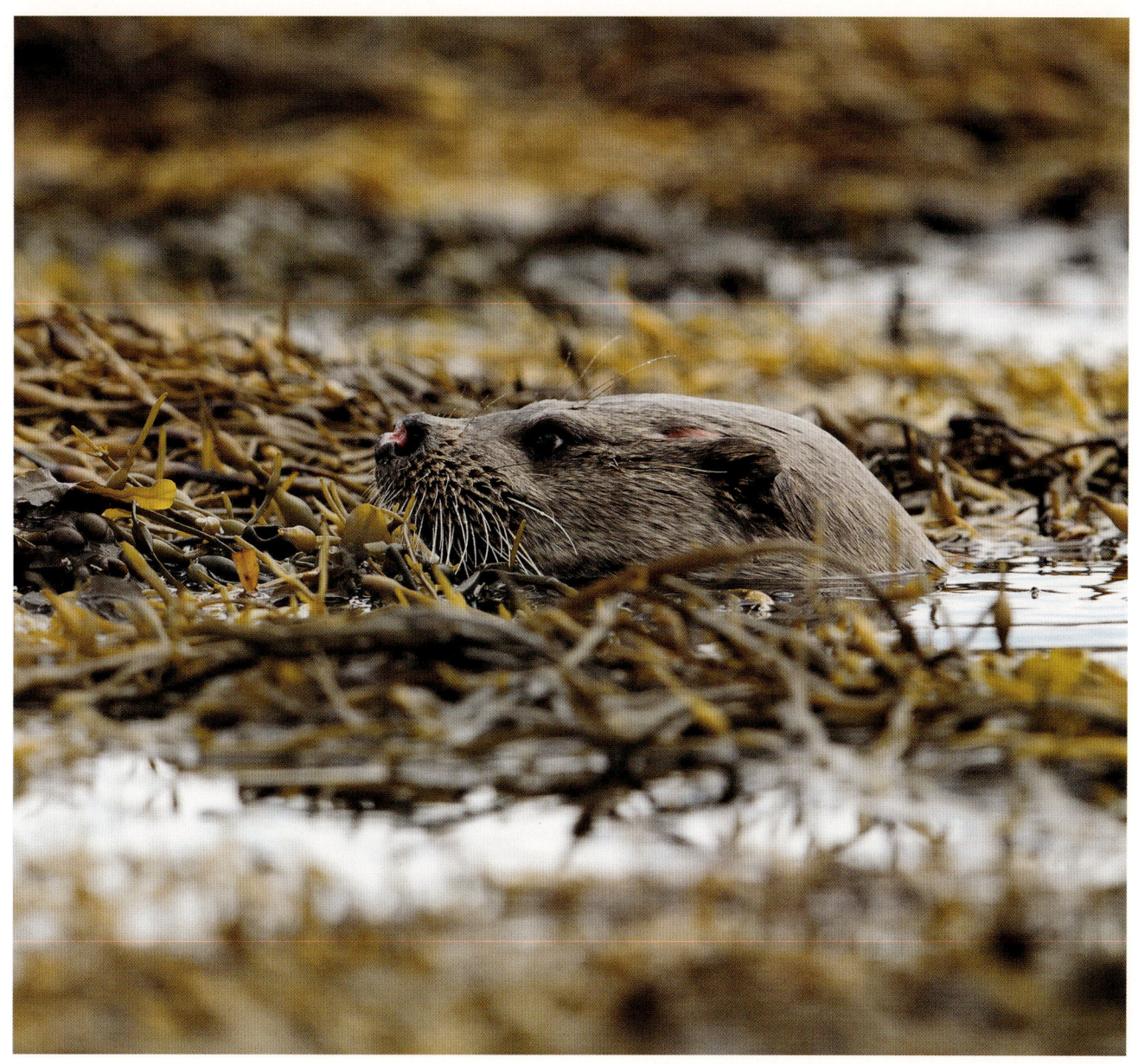

Left: Always *en garde*.
Above: Battle scarred dog otter.

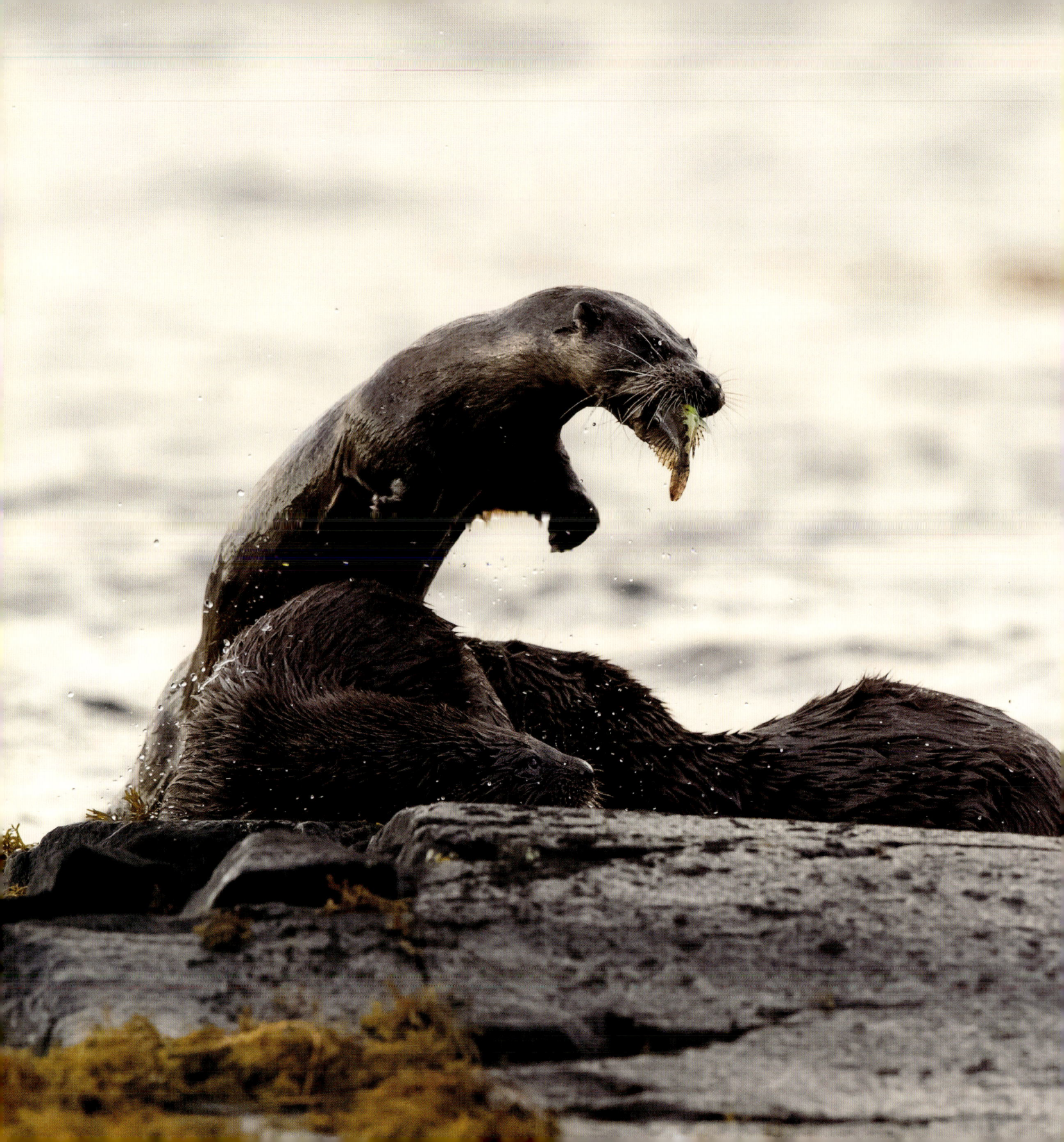

LEFT: Breakfast is served.
ABOVE: Playtime.

Exploring a skerry.

Field Note
Mating otters

While driving beside a sea loch at little more than a crawl I heard a commotion, a high-pitched squealing that echoed across the still water. It was two otters interacting but for what reason was not immediately apparent. Bringing the vehicle to a halt, I gathered my camera and binoculars and scanned the shoreline for movement.

With the surface so still, it took just a few seconds to locate the source which, at first glance, I thought was a fight. Only after taking the first few frames did it dawn on me that they were mating. They rolled about, locked in ferocious embrace, for the next twenty minutes, the dog firmly gripping the bitch's neck with his strong bite. She became more agitated as the act drew to its natural conclusion, but then relaxed as he released his grip.

They went their separate ways without further ado.

Above: Going home.
Right: Scarface.

LEFT: Delighted with its first catch.

ABOVE: Mother preening cub.

LEFT: Rough play.
ABOVE: Angelic.

PREDICTABLY UNPREDICTABLE

Observe the animals year on year, and eventually something close to the whole picture will appear. Never the whole picture though, because the more I learn the more I understand how little I know. Fresh experience is continually being processed.

Standing at the edge of the machair at low tide, which is when most otters hunt, looking down into clear green water, I watched a familiar female roll into swaying kelp on the seabed, effectively her larder. Normally a sudden dart would signal success, after which she would lunge upwards, within a curtain of rising bubbles, to the surface with her prize. With such fluidity of movement, it seemed she was more an element of the ocean than a visitor, and indeed she plays her part in the balance of its ecology.

At the bottom, her colouring blended so perfectly with the seabed that I lost sight of her. Nothing unusual in that but, on this occasion, she was submerged for an inordinately long time and I began to worry. I should have known better! A vigorous whipping back and forth of the kelp was followed by a wriggling, untypically indirect ascent, an explosion of spray and a tangled mass of fury and violence at the surface. In her teeth was an eel as big as herself; as big, and almost as strong. Repeatedly it tried to dive and take her, entwined in its coils, with it. Eventually, but not inevitably, the powerful young otter dragged its unhappy prey ashore and finished it with a succession of bites to the head.

The eating was gargantuan, even for the otter's pressurised alimentary system, and after almost an hour she cached the remains to doze close by. On waking she dragged them back into the sea, swam along the shore and made another cache, this time under seaweed. No doubt she would return when she was hungry again, but by this time I had to leave.

The stare.

Otters in Shetland behave slightly differently to those living further south in such minor matters as preferring grass to roll on rather than seaweed, to keep their pelts from matting and losing its thermal properties. Both know their territory precisely: the shape of every boulder, the location of every stream, the safest drinking spots and the seasonal timing of nature's bounty. The horizon's contours are imprinted on their brains and they are suspicious of change.

They have shared locations where they spraint. In this shared space they leave scent messages that carry emotional signals and warnings, and in this way share community beyond immediate family. Out of the water their ability to sniff out a potential threat is their most essential defence mechanism. When the wind has shifted unkindly, I have watched them pick up my scent and immediately disappear among the boulders and waves. Amazingly, it doesn't end there; recent research has found that they use their super-sensitive noses to hunt underwater, breathing out bubbles and re-inhaling when they are infused with tiny scent molecules, a process that happens in the blink of an eye.

Their periods of rest may last only fifteen minutes or stretch into several hours, and this is when we can study

With conger eel.

their anatomy in detail: the almost hand-like paws with webbing between fingers and toes, the sensitive whiskers through which they detect the movement of their prey through the water. Their noses will often carry scars from crabs and lobsters, or from searching among sharp boulders.

I once watched a dog otter patrol all day and hunt into the evening, when it headed along the shoreline in the direction of a familiar holt. Bedtime apparently, so I followed, walking briskly. In fact, it set quite a pace, running here, swimming there, clambering over outcrops, and I found myself moving at a trot. When it arrived at a burn it turned uphill in determined fashion. I took a deep breath and followed.

As it moved in and out of sight, I intuited its general direction, and navigated more precisely by the sheep it scattered on its way. Foreseeing that it would eventually enter the burn to continue upstream, I made an educated guess and forged ahead, to crouch and wait in a good hiding place on the right side of the wind. So glad was I of the rest that I almost missed it when it swam past.

By now it was moving rapidly, pausing only to clamber round the burn's many waterfalls, which was when I would catch sight of it again. Intrigued, I followed without thought of distance or our height above the loch, but by now I was running to keep up. On many occasions I lost sight, only to catch a fleeting glimpse as the burn narrowed to become no wider than the otter itself, to lose sight again and give up, but… my eye was drawn to a patch of yellow grass that was glowing in the late evening sun. Bounding through was my indomitable quarry, but I was done. Out of breath and soaked with perspiration, I looked back and down. The otter had drawn me uphill for well over a mile.

Weeks later I revisited with time and breath enough to locate what was obviously an active holt. Ever adaptable, ever surprising, it was a second home from which the otter could vary its diet, no doubt with rabbit or hare.

The toolbox.

LEFT: A questioning look.
ABOVE: An awkward itch.

Otter in the rain.

LEFT: Shetland wren.
ABOVE: Mink.

Rhapsody in silver and grey.

Field Note
The surfer

The cool, crisp autumnal light of high northern latitudes combined with clear Shetland water made this underwater shot possible. I had been seeking this opportunity for many months, a shot that could only be achieved in the crystal waters of Scotland.

As it was, this was my second attempt with the same otter a few days apart. All it took was timing, experience, judgement and… luck. The otter had caught a fish and was heading back to shore, surfing the swell as it approached the beach.

ABOVE: Shag.
RIGHT: Stowaway.

LEFT: Curious otter.
ABOVE: Drying off.

Above: Sleeping under the jetty.
Right: Precision preening.

Field Note
Close encounter

To be close to wildlife is a wonderful thing, but when wildlife comes to you it's even more special.

While tracking an otter along the shore on an especially wet and miserable day, I noticed that it was walking along the beach rather than following the more usual practice of swimming parallel to the shore. Deciding to take a risk, I raced ahead in anticipation of some rare approach shots.

Minutes later, lying flat on wet stones, I watched the animal move along the long sweeping curve of the open beach. As it hurried beside the water's edge, I flattened my tripod and waited. Soon it was walking directly towards me, coming closer, closer… and closer. I only stopped shooting when it got to within a few metres and I had to lower my head to avoid eye contact.

So close did it come that I could hear its footsteps on the stones as it walked past. Even more wondrously, it stopped to sniff my boots before leaving me behind.

Hebridean sunset.

LEFT: Crab for lunch.
ABOVE: Fish supper.

ABOVE: Cuteness overload.
RIGHT: Sideways glance.

Always aware.

A ROOM OF ONE'S OWN

Otters exist happily all over the main and other islands of Great Britain, from the clear, fresh chalk streams of the English Downs, where they feed exceptionally well on fat trout, to the wind-battered and salty North Sea archipelagos. Unlike some aquatic mammals such as the beaver, which can entirely alter a local ecology, the otter lives almost without trace, leaving little other than uneaten food, which is soon scavenged, pawprints, and mounds of spraint that grow through the generations, gradually petrifying into a stony permanence covered in vibrant green grass. I am thinking of a skerry in Shetland.

To observe and photograph them in every county would be quite a challenge, one I am more than content to leave for others. The constantly changing nature of Scotland's sea lochs appeals most to me, an environment that perfectly matches the otters' natural camouflage, with nooks and crannies for play and protection, and ensures them a rich diet.

Otters can be found across the globe. It was in the marsh country of Iraq that Gavin Maxwell adopted the first of his lifelong obsession. Named Chahalla it did not live long. River otters, two metres in length, swim in the Amazon, where they have been seen to hunt and kill much larger animals, including the mighty caiman, a sort of alligator, and giant anaconda. The sea otters of Canada and Alaska (of which more later) use stones balanced on their abdomens to smash their way into shellfish. The Canadian otters are fascinating to watch as they return from the depths with a selection of foods: crabs, clams, sea cucumbers. Each has its own special rock which it secures in the folds of its belly and uses as a sort of anvil.

The British and Irish populations crashed in the years following World War Two, with some ranges losing up to 95% of their populations as measured over a period of about twenty years. The insecticide DDT,

Sunset silhouette.

as Rachel Carson revealed in her famous book *Silent Spring*, was responsible for a great regression in the natural world and the otter decline was part of that. The poison would be ingested and passed from prey to predator, accumulating until it reached the higher levels of the food chain, resulting in birth defects and infertility. These dreadful chemicals were removed from agricultural use in the late 1970s, but for over sixty years a cocktail of toxins had been released into our waterways. Tremendous damage was done, and it took a radically altered public sensibility and much care to reverse it.

Thick, olive-coloured clumps of bladderwrack make the most comfortable of otter beds. Washed clean by the tide twice a day they are equally hygienic. Connoisseurs of comfort, otters have their favourite spots to which they return time and again. Ever resourceful, they will tear up long grasses and pile them in a sheltered spot behind a drystone dyke or in an abandoned outbuilding. Such a bed of grass is called a 'couch'. Old fishing nets are also used. Asleep on seaweed, the otter is perfectly camouflaged and almost impossible to locate. A casual passerby will never notice.

Spraint.

Holts can be found among rocky outcrops, dug into peat, occasionally on manmade breakwaters or, amazingly, inside the roots of ancient oaks when they are broken and rotted. Where an otter might choose to make its home ceased to amaze me after I observed one slumbering in a culvert under a busy road. Sensitive to both sounds and smell it slept the sleep of the just, although the constant rumbling of vehicles only a metre above would have kept a sloth awake.

My privileged life has taken me to some of the most remote locations of the United Kingdom, and to the further reaches of the Canadian wilderness, the sort of wild country where I feel most at ease and suppose the otters do too. Like me they prefer solitude, a clean environment and peace. I need refuge from the conflict and noise of human activity whether it be the barkers of commerce or news of unending war. Sanctuary is not too strong a word, although I know I must make my compromise and live between worlds.

A ferry cancellation once meant that I had to make a late booking into a harbour hotel in Oban, on my way back to Mull. It was mid-November, the first night of the town's Winter Festival, and ten days of celebration would follow. Families bustled along the promenade, and the air was thick with the smell of burgers and onion. As the pubs emptied and popular hits of the day rang out, I stood at the window of my room watching the families and young couples, the drunks and police come and go. The water surface was black under the starless sky, except where the festival lights reflected. Boats turned slowly on their moorings.

A slight movement took my attention, a familiar ring of light moving across the harbour, and a few moments later a head popped up to sniff the air. A dog otter was happily fishing just a few metres from hundreds of revellers. Although in close proximity it was undistracted, seemingly self-contained in the circle of its own life. It could not have been wholly oblivious to so much trivial noise but appeared to be so as it held to its own values and purpose, with just one kindred spirit looking on.

Shetland holt.

The Sound of Mull.

ABOVE: Matriarch.

RIGHT: Emerging from a rock pool.

Above: Time to relax.
Right: Down time.

Field Note
Otter and eagles

While photographing a pair of white-tailed eagles as they stood on a rocky outcrop, I spotted the familiar V-shape wake of an otter bringing its catch to shore. It was heading towards the eagles, who watched intently as it clambered nonchalantly onto their rock and began its meal.

The insult was too great for the eagles who took to the air with nefarious intent. Of course, a giant wingspan doesn't lend itself to sudden changes in direction. They had to fly out into the wind and make a wide loop to achieve their angle of approach.

The otter had the measure of them, and on each swoop would make a quick turn and evade them with ease. The eagles repeated their attacks until the otter decided that discretion is the better part of valour and took shelter under a rock to finish its meal undisturbed.

Evening light.

Above: Young otter in sparkly light.
Right: Otter in kelp.

LEFT: I'm shy!
ABOVE: Forty winks.

Shelter from the storm

Left: White tailed eagle.

Above: Puffin

Field Note

Shaken but not stirred

When this otter awoke from its afternoon nap, it gave itself a shake and headed straight for me. When it submerged to swim beneath the seaweed, I followed its progress by watching bubbles breaking on the surface.

As it closed on me, I quickly adjusted my camera settings in the hope of a single snatched image as it surfaced. This I managed, but without really knowing what I had captured.

Only when it was long gone did I dare to move, and to check the image screen. You can have all the skills in the world but sometimes Lady Luck has to hold your hand.

LEFT: Cleaning behind the ears.
ABOVE: Steady gaze.

On the prowl.

sunset stretch.

AT THE INTERTIDAL CAFÉ

Loaded with photographic equipment I stood at the edge of a great sea loch, watching an otter as it watched a Slavonian Grebe, the grebe also being watched by a huge black shag standing on a boulder. As the otter dipped under the surface, with obvious intent, I moved into position. A picture of it taking the grebe would be a rare treasure. To my surprise though, and to the greater surprise of the shag, it rose from underwater to bite into the larger bird's wing. I was hastening to set up when the action was interrupted by a barking dog. The otter left the shag to flap wearily shorewards and eventually expire of fright, by which time the grebe was nowhere to be seen.

Within a diet that consists entirely of meat and water the otter's preferences range widely. They can and do hunt for rabbit and mountain hare but are not averse to taking domestic birds. I have a crofter friend who keeps both chickens and ducks, but insists they prefer ducks. She tells a good story against herself of an old otter whose antics around the croft the family had enjoyed watching, and how she chased it across the yard with a broom until it dropped her disgruntled duck. Yes, it was a love/hate relationship. They will take chickens as singles and not indulge in the sort of hen house slaughter that pine martens and foxes are guilty of.

Inevitably for a semi-aquatic mammal, most of their diet comes out of the water: both the fresh waters of rivers, and the salt intertidal zone and shallows of the coast. A sea trout or a salmon taken from a Highland river might provide several sittings with little left for other animals. However, the days after the salmon run, when the fish have spawned in the place of their birth, and many are weakened and die, is a time of genuine bounty for the otters. So much so that they can afford to be selective, taking the highly prized gills and softer tissues and leaving the rest for creatures further down the food chain.

Catch of the day.

They also drink a lot of fresh water, which is probably not surprising when they eat so much saltwater fish. They can survive on rain trapped in rock pools, but rarely range more than a kilometre from a good, reliable supply: a lochan, or a hill stream where it meets the sea.

Come Spring, frogs gather to spawn, and soon the lochans are positively heaving with them. Now the otters head up the burns and ditches to feast among the standing waters of the hills and woodlands, leaving the unpalatable skins and heads gruesomely discarded. The multitudinous number of frogs mean the otters have little effect on the overall population.

The animals I spend most of my time with are master fishers of all creatures that inhabit the tidal waters of coastal Scotland. Eelpout and butterfish are their most frequent prey, and it is not uncommon in the Hebrides to see an otter succeed on almost every dive. Smaller fish, such as these, are easy to handle and can be consumed while treading water. Larger prey is dragged ashore, often after epic tussles.

The cool, nutrient rich waters of the Hebrides are perfect for spawning, and make ideal nurseries for juvenile fish, but to enter the shallows is risky and this is the fatal last mistake of many. Large fish, which provide big meals, work to my benefit if I can ease myself into a good, unthreatening position. The otters are generally reluctant to abandon food, which gives me confidence to approach more closely than I would otherwise do.

Salmon leftovers.

A nap usually follows, which, again, can provide fine images.

Photographing wildlife has brought me some of my life's most wondrous experiences, many of which could have been neither foreseen nor planned. One summer evening I sat in an atmosphere of stillness and near silence, made as much aware of the sea's power by its deep swell as I would by any storm. The atmosphere was thick and muggy. 'Close' as the Scots say, close enough to send you to sleep. All was calm but changed in a moment when the surface was transformed by shimmering movement. Millions upon millions of sand eel fry had swept upwards with, beneath them, a great gathering of dark backs and iridescent sides moving in perfect choreography. A shoal of mackerel was hunting as with a single mind, rolling with a controlled urgency formed by long evolution. Lunging towards its prey it created panic and confusion until the silvery fry scattered like sparks in every direction.

Behind the mackerel came the larger mammals: porpoises, which brought me to my feet, and the unmistakable grey back of a minke whale as it carved the surface. The panicked sand eels flew out of the water to land on rocks and rafts of floating seaweed. Some made it back, but most did not and over those hovered gulls and crows come late to the feast, sweeping in from nowhere.

When all is frantic, be calm. A familiar otter was lying on seaweed where the waves lapped the shore, taking her ease while eating to repletion. She had all she needed and deemed it enough, but it was a timely feed as she was due to give birth soon.

Otter trail to a frogging pool.

Above: Otter with scorpion fish.
Right: Otter with cod.

A knowing look.

LEFT: Otter with common skate.
ABOVE: Going... going... gone.

Above: Common or harbour seal.

Right: Grey heron.

Field Note
Otter cub and rockling

While watching a young otter fishing offshore, I counted the seconds of the many times it dived before finally breaking the surface with a substantial catch and dashing for where I lay. My heart raced as it landed a jazzy looking fish called a three-bearded rockling on a seaweed covered boulder in front of me.

Suddenly, the rockling made one last bid for freedom by flinging itself across the seaweed in my direction! Not suddenly enough though, the otter grabbed and devoured it on the spot. It was a sad end for a beautiful fish, but it made both otter and photographer very content.

ABOVE: Otter with dogfish 1.
RIGHT: Otter with dogfish 2.

At the water's edge

LEFT: Otter with crab.

ABOVE: Otter with octopus tentacle.

ABOVE: Otter with octopus.
RIGHT: Unusual behaviour, eating a jellyfish.

Field Note
Modern day piracy

Piracy is still alive and well in Scotland's Outer Hebrides. A young otter of my acquaintance had a highly developed taste for octopus but so, as it proved, had a local pair of hooded crows.

As my otter consumed its octopus on the shore, one of the hoodies strutted confidently across to stand in front, with the other moving sneakily to the rear. In a co-ordinated move the second crow pulled sharply on the otter's tail, and when it looked around, in a flash, the rest of the octopus was lost to the first.

A week later the same tactic was deployed by the same crows on the same young otter, although on this occasion it refused to turn even as crow number two wildly increased the ferocity of its jabs. This young cub was not much older, but a whole lot wiser.

LEFT: Otter with eelpout.
ABOVE: Shared lunch.

ABOVE: Otter with rockling.
RIGHT: Treading water.

ABOVE: Snooze after feasting.

RIGHT: Intensity.

Hide and seek.

MOTHER NATURE

The male otter takes no interest in his offspring and is likely to have several litters at any one time within his savagely held territory. Family commitment amounts to 'mine' and 'more' without further foresight or caring. His reproductive life though, is not likely to extend beyond two, possibly three, generations, and the oldest of them will not become fertile before his time is past. We no longer believe in a personified Mother Nature but, if she existed, we could agree that she is uncannily wise.

Welcome then, to the mother-and-cubs ambience of the otter family, where education and play are one and co-operation across the generations is a given. The otter mother enjoys an emotional bond of such power with her cubs that she is among the best parents in the mammalian world. A significant part of her time is spent grooming her cubs' pelts, which maintains their insulation qualities in addition to keeping them clean. She is their only provider throughout the early months (when the dominant cub will take most of the food). Safety comes with the provision of a warm, dry holt, security within a protective aura of primal intensity.

Play is at the same time learning, and holds great charm for watching humans, especially when Mum joins the melée. A 'ball of otters' is how I think of them when they are rough and tumbling. Good education is the key to familial success, meaning survival into and through adulthood: where to find drinking water, how to hunt, the rudiments of otter safety. From birth to dispersal takes fifteen to eighteen months.

The matriarch of such a family was one of my more confiding otters, only one of whose previous litter had reached maturity, a female now raising her own first cub nearby. The experienced mother had a second litter of two, who had now begun their venture towards independence, and had no doubt learned from experience. She operated within a strict efficiency of

Sqabbling over a fish.

time, leaving the holt an hour before low water and remaining out until high.

One morning I watched the family from behind a boulder as they returned along a well-worn path, instinctively making myself small while listening to their paws on the ground, trundling by so close I could have touched them… but one cub was missing. I looked around and, to my horror, saw it close by. When Mum came back to investigate, I remained still, understanding she would see me as a blur and hoping she would not catch my scent. She hissed in my direction to goad a reaction. Not receiving one, she stood upright on her hind legs and made a low growl, which called the cub to her, and escorted him to his sister. I was left breathless but spent the remainder of the day photographing them fishing, playing and at rest, counting my blessings.

Weeks later I watched the cubs on their own, mother having left them in the same safe location as her previous litters. Like all young animals, when left alone they got up to mischief, rolling on their backs, tossing pieces of kelp into the air, wrestling and exploring. The dog, who was the stronger and more boisterous, from about eight months took an inappropriate interest in his sister, much to her indignation. This led to more fights than I had seen in any other otter family.

As my stay near the loch drew towards its end, the confrontations grew more violent but, by my next trip a month later, matters had somehow been resolved. Mother and daughter were living contentedly together while the amorous son fended for himself elsewhere within the territory. No doubt avoiding his father.

Well used otter track.

The cubs exit the holt for the first time at three months with a natural reluctance to enter the water. Their tiny, fluffy bodies have little bone density or muscle tone, so diving is difficult for the first couple of weeks. During this initial period, they bob on the waves, growing accustomed to their new environment and gaining confidence. Play consists of hiding among seaweed, nipping each other's tails and scampering along the shoreline. I watched a pair as they played hide and seek around a rock pool, one submerged beneath seaweed, the other searching and calling. When a mock attack was launched from behind a stone a rolling ruckus ensued. It is hard not to smile.

In sheltered inland waters it is normal for two cubs to reach adulthood. Three is possible and four rare. Four bears testimony to the mother's unwavering dedication. They are often lost to bad weather and newcomer adult males. Eagles will sometimes take one but will avoid confrontation as they cannot risk a bite.

A cub separated from the family will call with a high-frequency whistle that can cut through the wind for a surprising distance, and this is often the clue that takes me to an otter family location. Mother will announce her return with a deeper whistle, a less urgent, more reassuring sound to which the cubs respond warmly. By the time she takes them fishing they are likely to be reduced in number to one or two, whose stamina will be limited, who may tire suddenly in the water and, in those circumstances, ride on the soft strength of her back to the safety of the holt.

Staying close to Mum.

Above: I'm bored, Mum.
Right: Family portrait.

Study in ochre and brown.

ABOVE: Cub peeking from behind Mum.
RIGHT: Cub in hot pursuit.

Left: Cub in the surf.
Above: Rough and tumble.

Field Note
Family of four

Scanning the shoreline with my binoculars for traces of otter, it took no more than a few seconds to spot not one but two, a bitch with her cub. Happy days!

The descent to the beach was steep and would seem even steeper on the way back, but I took my courage in hand along with my equipment and headed down. Setting up as close as I dared, I suddenly noticed there were two cubs… then three, playing on a rocky promontory.

This super-mother had managed to raise three cubs to near adulthood, and how they had eluded me for so long would remain a mystery. I was elated by her success.

LEFT: Calling for Mum.
ABOVE: Tussle with pipe fish.

Piggy back.

ABOVE: Safe and dry.
RIGHT: Wet and wonderful.

ABOVE: Young dog otter.

RIGHT: Play fight.

— Field Note —
Fully insured

Photographing wildlife is not without hazards. In the case of otter photography: slippery rocks.

I had been following the progress of this family for some time. Mum was a successful hunter and the two cubs were boisterous and well fed. They were playing gleefully with mother fishing nearby just prior to this picture being taken. Shortly after, still lost in concentration and unbalanced by the weight of my camera and tripod, I lost my footing and fell backwards into the loch fully clothed. I remember looking upwards to see green bubbles racing to the surface, only just managing to struggle ashore.

It was a close thing, and I took a few minutes to recover before stripping off and diving back into the loch to retrieve my equipment. Salt water and hi-tech cameras do not mix well but, fortunately for me, the insurance company replaced both camera and lens.

Most amazingly, the otters paid no attention to me flailing around in their environment. They just carried on.

Above: Suckling cub.
Right: Cub with wrasse.

Playing at high tide.

Above: Very young cub.
Right: Curious cub.

LEFT: Mum brought this.
ABOVE: Riding to shore on Mum's back.

THE SEA OTTERS OF VANCOUVER ISLAND

From the gunwales of our boat we looked down through a barely perceptible surface onto translucent creatures, strange to our eyes: zooplankton, comb jellyfish and more, the tiny organisms that fuel the ecosystem from the bottom of the food chain up. It was like looking down on galaxies. Below them moved a dense layer, almost a mosaic, of Pacific salmon, in numbers I would not have thought possible from the Scottish experience.

At 50⁰ north, Vancouver Island is at a comparable latitude to my usual otter haunts, but the quality of light is altered by the proximity of dense, primal forests of Douglas and Sitka spruce, Sequoia and other firs. The First Nation people who live here have remained in co-operation with these woods, taking only what they need from individual trees and leaving them still alive. Clear felling is anathema, and because of this wolves and cougar live here.

We had chartered a skipper and his boat for the day and gone in search of the sea otters that were reintroduced from Alaskan stock in the 1990s, the originals having been hunted to extinction for their super-dense pelts, the thickest in the animal kingdom. In roughly a quarter of a century, eighty-nine had become over three thousand.

Within minutes we were watching a humpback whale sound, listening to the great *whoosh* of its breath as it spouted. I had not expected such force. Soon a pair of bald eagles appeared, taking fish from just below the surface. I am familiar with their Scottish cousins on Mull, the white-tailed sea eagles whose methods and grace strike me as being similar. When it dawned on us that we were about to enter the Pacific Ocean, and to carry on would be to end up in Japan, we suddenly felt small and insignificant, not only against the scale of the ocean but also in time.

Sea otter.

Miles of shoreline whizzed past as we slalomed between tiny islands, all of which were vibrant with life: sea lions, eagles, eider, geese. It was early October and cool. Ribbons of cloud clung to the mountains.

Sea otters were high on our list of must-see wildlife when my wife, Lyndsey, and I made our first trip to Canada and a chance meeting put us in touch with a fisherman who knew where there was a small family group or 'raft'. These sea otters are typically more than twice the size of the otters I knew so well. They have different, although equally expressive, faces with large Roman noses. They are tool users in that they will balance stones on their tummies and smash shells on them to get to the succulent flesh within, and to do this will float on their backs which our otters will not. Where Eurasian otter young are called cubs, Pacific otters have pups.

Every now and then the mountainous terrain opened onto lush, green delta land, until suddenly the skipper changed course and entered one of these secret bays. A black bear was foraging on the shore, lazily grazing on lush grasses. Disturbed by us, but not frightened, it watched with obvious curiosity as we passed.

Another hour took us to the otters. Some were dozing on sea kelp, others diving for clams, crabs, fish – whatever gave them sustenance. We were thrilled to find females with pups. They are born fully furred, and mum will blow air into their pelts to aid both insulation and flotation. For much of the time the pup will suckle as she reclines on her back; again, a subtle difference from our more familiar otters. They live almost exclusively in the water, rarely venturing ashore.

Understanding that these animals were not familiar with boats, we approached with care, erring always on the side of caution but, when they grew accustomed to us, drifted closer to watch with joy in our hearts. Our first visit was a success.

A year later we returned to the island but to a different location, a hamlet of twenty-five wooden houses at the end of a bumpy six-hour drive, each with a boardwalk and a jetty suitable for mooring a seaplane. This is a bolt hole for Vancouver and Seattle's wealthy elite, but we had not come to hobnob with the fur-coated glitterati. Our interest was with fur clad creatures of a different ilk.

After seeking permission to access the boardwalks we were delighted to find otters foraging close to the jetties, surfacing with as many as three food items at a time from what was obviously a well-stocked larder: urchins, crabs, clams, and sea cucumbers, the latter popping like balloons with the first powerful bite. We would wait for an otter to dive before throwing ourselves down as close as possible. The surfacing otters ignored us if we remained still, concentrating noisily on their seafood smorgasbord.

The Pacific otters are a conservation triumph, but their environment is equally if not more so. There is no pristine wilderness left in the world, but the Canadian North West is the least damaged ecosystem I know. Its wildlife is varied and plentiful, self-sustaining and in balance. Its forests are among the great lungs of the northern hemisphere. It provides a rough model for what we might achieve with a more considered approach to management of our wild lands, a template for what is possible.

Sea otter habitat.

ABOVE: In search of sea otters.

RIGHT: Air taxi seaplane.

ABOVE: Sea otter with clams.
RIGHT: Mother and pup.

Crunch time.

LEFT: Preening at sea.
ABOVE: Sea otter with sea cucumber.

Field Note
The lunge

For wildlife photographers it is important to capture the essence of a location and shooting with a wider lens helps tell more of a story.

On a whale watching trip out of Port McNeil we drifted with engines off, our attention taken by a commotion on the surface. Hundreds of seabirds were feasting on something, soon to be joined by sea lions, dolphins, and porpoises. It was a shoal of fish that, threatened by predators, had sought safety in numbers by forming into a sort of underwater ball.

Suddenly, the seabird heads lifted almost as one and they rose in flight from the surface. They had sensed what was on the way, a humpback whale lunging to the surface, scooping up fish in its cavernous mouth. It was a breathtaking experience.

LEFT: Humback whale spout.
ABOVE: Humpback tail fluke.

Stormy inlet.

ABOVE: Sea otter reflection.
RIGHT: Sea otter with crab.

Field Note
Tears of joy

Since I was a young boy, I have dreamed of seeing orca, such magnificent animals, up close. They were among our principal reasons for visiting Canada. However, they evaded us on our first whale watching trip.

On the second, while cruising for miles down a narrow sound in search, I joked with the skipper that I would like a backlit orca in dark water. To my surprise, he gave me the thumbs-up and said, 'no problem'.

When we stopped for lunch, drifting on mirror flat water, I heard the unmistakable blows of whales. Dozens of them! A pod of thirty orca were heading for the boat, with one cow taking up the most perfect position I could have visualised in my dream encounter.

The skipper looked at me with a wry smile and winked, as tears of joy rolled down my cheeks.

ABOVE: Black bear.
RIGHT: Bald eagle.

Suckling pup.

ABOVE: Pacific white-sided dolphin.
RIGHT: Bull orca.

Dark water sea otter.

CODA:
Close to Home

From the wide windows of Fortrose Academy's upper floor classrooms, the view along Chanonry Ness, the narrow spit of land (actually a 'glacial terminal moraine') that stretches into the Moray Firth, is immense. I know because I spent so much time gazing through them. I have been an outdoor person since those long, wild summers on Mull, but now I was confined and stifled and longed to be free.

At the end of the peninsula is Chanonry Point, which is one of the best places in Britain to observe bottlenose dolphins, especially when the salmon are returning to the Rivers Ness and Beauly. Each day I longed for solitude and the wild, and often in the evening would cycle out to sit contemplatively on the old stone jetty.

One summer's evening my attention was caught by a circle of light that steadily grew larger and closer in the water. Too small to be a dolphin, could it be a sea trout? No, too large. A seal then, I thought, probably a seal; but when a small, terrier-like head popped up I saw it was an otter, my first on the mainland. I flattened on my belly with my chin resting on folded arms and my heart beating so hard I thought it might give me away.

It hauled itself onto the jetty, apparently without noticing me, its long body so low in the middle it almost touched the ground. Its short legs were thick and powerful, and its tail curled upwards to point at the sky. It was magnificent. After a vigorous shake it walked in my direction until the gentlest of breezes gave me away and it slipped back into the water.

That encounter opened my eyes to the presence of otters nearby, and as I gradually widened my circle of experience I observed them below the bridges in bustling Inverness, on local, popular beaches, and while fishing the great salmon rivers, and it struck me as important that neither locals nor tourists were truly aware of the wonders at their feet. Looking, they seldom saw.

Bottlenose dolphins.

In my late teens I was owned by a beloved Labrador. Cas took his name from Corrie Cas, in the Cairngorms, and ate anything that came within range of his nose. On one morning walk he came back, on call, with a lumpsucker fish in his mouth. The poor creature was still flapping, but well past survival with half of its head missing. Judging by the teeth marks, an otter must have taken the rest. As a family, we never guessed that we had otters for neighbours. The lesson taken then, and never forgotten, is how close wildlife is to us when we are thinking of, and living for, other things.

Lyndsey and I have friends on the Isle of Skye, who wondered which neighbour's cat was sneaking in to clean out their own cat's saucer when all backs were turned. The mystery remained unsolved until one morning they were wakened by a knocking sound from the kitchen. On investigation they found an otter pushing the saucer against the kitchen door as it licked it clean.

Another time, on Shetland, John Moncrieff and I were returning from a lead given by our Facebook group (that alerts us to fresh orca and humpback whale sightings) when we came across a young otter, apparently homeward bound. As we followed it up the beach, across the road and through a field, I joked that it was heading for John's house. A joke, yes, but when it slipped under his fence and casually trotted past his back door we had to investigate further. After much searching, we found it curled up under his shed. For how long it had been squatting we could not begin to guess, but it remained for several more weeks.

For years I have taken at least some of my sport, with many other anglers, on the River Findhorn. One overcast day, with the river level falling post spate, perfect conditions for fishing, I instinctively felt that a fish was close. Slowly and carefully I worked my way downstream, taking one step after each cast, to approach a familiar hotspot where salmon would often rest with a gentle glide of water passing through their gills. No draw on the line materialised, and I was confused by the lack of movement. Not a fin had I seen, nor the swirl of a fish to my fly, but a dipper appeared on the far bank.

Like a dumpy round blackbird, chestnut brown with a bright white bib, the delightful wee bird was bobbing to the river's beat when it suddenly took flight. Something had spooked it, and that something turned out to be a stoat, which I watched as it worked its way over, under and through the rocks. When a string of bubbles appeared close to where I stood, it vanished into the long grass. The originator of the bubbles broke the surface and was, of course, an otter, the next step up the hierarchy of predators, which also explained the absence of salmon. Stoat and otter are related, both are mustelids, but the otter is by far the more formidable. I tell this story as many anglers concentrate so completely on their activity that they can fail to notice even the passage of animal life and death occurring before their eyes.

Nature is closer to us than we think. There are foxes in the city, raptors nesting on office blocks. The thing to do is learn to read the landscape. If your interests are wider than your immediate activity, or you take a more nature-centred view of our place in the world, ask this question: what animals might thrive in such place? Chances are the expected animals are present.

My sense is that the boundaries are becoming blurred, that what was once a bloody frontier is becoming shared ground and that a better balance is possible. This understanding no doubt takes us into a consideration of such wider questions as the climate crisis and single use plastics, but I will return to the secure ground of my own expertise and the tourist hotspot that is the Great Glen.

One animal that is not likely to be found there is the legendary inhabitant of Loch Ness. Believe in the monster if you will, but the accepted, often photographed, profile of three humps is the typical shape of an otter when it swims across still water, and many otters inhabit Loch Ness. The difficulty of perspective, when there is neither boat nor boulder to give scale, accounts for the size discrepancy.

There is a real monster though, that has cruelly depleted not only Scotland's animal populations, but diminished its forests and polluted its waters. Disturb an otter, one of these beautiful, supremely adaptable creatures, as it swims, three humped, across your lens, make some small noise, or let your scent be carried to it by the breeze, and it will make itself small by turning towards you, its myopic eyes and trembling nose pointing with unerring accuracy at its only real enemy, its relentless persecutor over the centuries. We must make peace with the wild.

Credit: Ruth Rowlands.

Appendix
How to photograph otters

Otters are legally protected. For guides who are also champions of the species, as I am, here lies a dilemma. This book is intended to inspire as well as inform and sensitise, but the less intrusion into their lives the better. If you must go out, go with the utmost respect for the animals, their environment, and the people who make their lives and their livings close by.

Experts such as my foreword author for this volume, Gordon Buchanan, have many years of experience and can gauge just how close is safe. With otters, subtle readings of demeanour and body language, as well as the direction and speed of the wind, and the condition of the tide, must be made to facilitate encounters. It would be untruthful to claim that I never disturb otters, but I minimise disturbance in every way I can. By adhering to the guidance below, and creating a few self-rules of their own, I hope photographers will create their own special moments with the otters having no notion of their presence.

Nothing beats local knowledge, so do not be frightened to ask a friendly local where to find an otter.

Use of a professional guide will all but guarantee success. Paying for knowledge will not only save countless hours of searching but also short circuit the long error-strewn road to experience.

Looking for signs is where fieldcraft comes into its own. Otters like to leave messages for other otters using spraint. Look for the brightest patch of green grass as otter spraint is high in nitrogen and a perfect fertiliser. They will habitually follow the same route to the water's edge, so look for otter-wide tracks. Half-eaten fish, crabs and lobsters are another indicator.

On flat calm days, sounds and smells carry great distances across water and, usually, an otter will be aware of you before you are of it. A gentle breeze is better, on shore or into your face but, personally, I prefer to photograph otters on stormy days when I can get much closer and the wind masks the sound of my shutter.

With an otter located, stop; be calm and observe. If swimming parallel to land it is probably heading homeward. If fishing, it may bring a catch to the bank or shore, and a promontory or rocky outcrop is likely. Stay quiet but count how long a dive lasts and only move when the animal is underwater.

If it stops to stare in your direction, more than likely it has sensed your presence.

Consider your approach. Ensure you are not silhouetted against the skyline by utilising landscape features to disguise your presence. You might sit in front of a large boulder or below an overhanging bank.

Dark clothing is essential, preferably camouflage.

Often otters will come towards you accidentally. If so, freeze and let the otter act to its own agenda. This can be a heart thumping moment. If it disappears, wait at least ten minutes because, often, it will still be around. Otherwise, retreat as stealthily as you can.

Take in your surroundings as no photograph or video will ever capture the essence of what you are experiencing. A good encounter is like an alignment of the planets with otter, weather, light, background, your inner being and mood, perfectly arranged for photographic opportunity. Nothing can possibly match or supersede 'the moment'. Savour that moment.

Savour that moment.

Credit: Lyndsey Howard.